Masaccio

MASTER ARTISTS LIBRARY

Series directed by
Antonio Paolucci

This edition published in 1998 by SMITHMARK Publishers,
a division of U.S. Media Holdings, Inc.,
115 West 18th Street, New York, NY 10011.

SMITHMARK books are available for bulk purchase for sales promotion and premium use.
For details write or call the manager of special sales,
SMITHMARK Publishers, 115 West 18th Street, New York, NY 10011.

Library of Congress Cataloging-In-Publication Data Is Available
ISBN: 0-7651-0866-6

Printed in Italy

10 9 8 7 6 5 4 3 2 1

Graphic design: Auro Lecci
Layout: Nina Peci
Prepress: Bluprint
Printed by: Grafedit

Masaccio

Richard Fremantle

SMITHMARK

The essence of the Renaissance lay not in any sudden discovery of classical civilization but rather, in the use which was made by classical models to test the authority underlying conventional taste and wisdom. It is incomprehensible without reference to the depths of disrepute into which the medieval Church, the previous font of all authority, had fallen. In this the Renaissance was part and parcel of the same movement which resulted in religious reforms.

No simple chronological framework can be imposed on the Renaissance. Literary historians look for its origins in the fourteenth-century songs and sonnets of Petrarch, who observed human emotions for their own sake. Art historians look back to the painters Giotto and Masaccio (1401–28), to the architect Filippo Brunelleschi (1379–1446), who measured the dome of the Pantheon in Rome in order to build a still more daring dome for the cathedral in Florence, or to the sculptors Ghiberti (1378–1455) and Donatello (1386–1466). Political historians look back to Niccolò Machiavelli (1469–1527), who first explained the mechanics of politics as power for power's sake. Every one of these pioneers was a Florentine. As the first home of the Renaissance, Florence can fairly lay claim to be the mother of modern Europe.

Norman Davies, *Europe: A History*, 1996

For A.F. and C.F.

Masaccio

To understand any revolutionary figure, one needs to dig deeply and find roots—not only roots for the figure, but the roots of the time in which he lived. So it is with Masaccio, who caused a revolution in painting so enormous that only over four hundred years later, with the development of the photograph, did his conception of painting and of the world come to a sort of popular culmination. The photo—and even more, the motion picture, which is, after all, a sort of modern and moving fresco projected up onto a wall—meant that even the least educated, the least skilled, and the poorest could own, appreciate, and make pictures like those Masaccio had invented.

His revolution was not only abstract and spiritual in the sense that he gave us a new way of expressing our feelings and our ideas. Using new conceptions of color and form, these visions became almost real. He showed how to use light and space, shading and edging, and colors manipulated by the artist to bring forth innate physical forces beyond their traditional Christian symbolism. Masaccio showed how the eye, like light, seems to cast a beam that falls directly upon objects, but can only imagine or suggest what lies behind them—thus adding mystery and drama. He taught how apparent empty space can become as positive and even as solid in a picture as any tangible object in nature, and how space can symbolize freedom of movement and of thought. He taught us the value and beauty of nature, of ourselves as an integral part of nature, and, above all, of our minds. Before Masaccio's time, the mind was of little importance in painting, compared with the soul. After Masaccio, the mind—thought—becomes the basis of reality. Not only is the picture real, but the projections of the mind, of thought, inside the picture are real also, perhaps even more real than other natural objects.

In the medieval world, man was merely another piece of the great mind of God, together with all other things. Masaccio—and Renaissance thought in general—turns that inside out: the mind of man becomes the center of existence.

By making us use our eyes in a new way, he pulled us all into the picture, and made the unreal real. In this sense, he made whatever the picture portrays true. And so he invented visual memories for us of things and happenings that had never been, but that seemed more real than what had actually been, because we could not only see them but because we felt to be there, too, in the scene that never was. This again foresaw the eventual arrival of the photograph and the selected political view of something, used for "propaganda," as we call it today.

Masaccio's roots go back as far as Christianity's earliest days, for Masaccio was not only profoundly Christian—foremost, a maker of sacred Christian objects—he was obviously a passionate advocate of the renewal of Christian forms to conform to the then powerful and long-existing desire for a renewal of Christian thought and practice. This desire for Christian renewal developed with particular force in the Florentine world all around him in the decades before his birth, during the years of his childhood and adolescence, and during his working years.

A desire for a more personal and lay Christianity is the catalyst for the massive change in form that appears in the first half of the fifteenth century—from Jacopo della Quercia's *Ilaria del Carretto* tomb of 1406, in the Lucca cathedral, to the work of Filippo Lippi, of Uccello, Domenico Veneziano and Piero della Francesca in the 1440s and 1450s, the period called the early Renaissance. The desire for change grew from a reaction to—even a revulsion of—the great wealth and poor behaviors of the popes themselves, and the papal administrators, a reaction that was already of great force a hundred years before Masaccio's birth, at the beginning of the fourteenth century, when the French king, Philip the Fair, put Pope Bonifacio VIII on trial *in absentia*. And the hundred years before that saw the massive reforms of Saint Francis and Saint Dominic. This revulsion continued throughout the fourteenth century in the works of such writers and thinkers as Marsilio of Padua, William of Ockham, John Wycliffe at Oxford, and then Jan Hus in Prague in the early fifteenth century, all of whom advocated the abolition of the papacy, and a return to a more private and personal Christianity, as did Luther a hundred years later. The apex of this antipapal feeling, particularly in Florence, occurred during the bloody war the city fought against papal armies in 1375–78, the so-called *War of the Eight Saints*, and then in the four subsequent decades of the greatest crisis ever for European Christianity, the *Great Schism* of 1378–1417. These were precisely the years of the birth and youth of Masaccio's mother and father, and of his own youth and training.

How could Masaccio, clearly a great thinker and a great craftsman, a Florentine of this tumultuous time, have been otherwise? Any figure involved on a primary level in the enormous intellectual force that brought forth early Renaissance ideas, in any of their major forms, must have been, first of all, a profound Christian, and second, a revolutionary. Are not Brunelleschi's light- and thought-filled churches a revolution in architectural form, a reflection of a new wish to reform Christianity? Are not Donatello's effete, frail, human-oriented, humanistic forms a revolutionary way to express man's true force in nature, a spiritual force parallel to his own intense Christianity? And Jacopo della Quercia's search for freedom and mass among the leftovers of ancient Rome—is this not also a way of breaking with the medieval past to give new forms—a reformation—to Christianity?

Not since fifth-century Greece had Europe seen the vast scale of cultural ferment and change that happened massively all over Italy, but particularly in Florence in the first half of the fifteenth century. Masaccio was among the greatest thinkers and greatest craftsmen of that cultural explosion. And because he was the inventor of a completely convincing, but unreal, new pictorial world where man's abstract dreams about freedom and truth could reflect his own growing wonder about his place in nature, Masaccio was perhaps the greatest of all those early heroic figures. Unlike sculpture and architecture, the art he developed and projected had little precedent. The medieval world—over four hundred years long—was one of tremendous development of architecture and sculpture. Only at the end of that period did painting become a prolific art precisely because of its capacity to illustrate ordinary human beings in the natural world. In this new art, Masaccio became the towering wave in a sea of change.

The name *Masaccio* is derived from Tommaso: Tommasaccio, which is then shortened. The suffix *-accio* probably meant "big" or "rough," so Masaccio would have meant something like "Big Tom" or "Rough Tommy." This name may also have been conferred on Masaccio to distinguish him from Masolino (1383–c.1447)—"Dainty" or "Little" Tom, with whom he worked on a number of occasions. But probably, it was simply because he was big.

"Masaccio" as a nickname does not appear, as far as we know, in Masaccio's lifetime. But Alberti, the architect and theoretician, uses it in about 1435, only a few years after the painter's death, in his famous treatise *On Painting*. And it reappears towards the end of the century in a manuscript attributed to Antonio Manetti, which quotes Masaccio's brother using the nickname.

Masaccio was born Tommaso di Ser Giovanni Cassai, on Saint Thomas's Day, 21 December 1401, in what is now San Giovanni Valdarno. Then it was called Castel San Giovanni, and was one of the new fortified towns Florence had built about one hundred years previously to protect its outlying districts. Probably, in Masaccio's time, San Giovanni garrisoned troops. Certainly, the town was a local administrative center.

Masaccio's father's family were well-to-do, as they lived on one of the main streets, and Masaccio's father, Ser Giovanni di Simone d'Andreuccio, was a notary, an educated official who could prepare, witness, and officiate legal documents—in effect, a minor lawyer. His mother's family—she was called Monna Jacopa di Martinuzzo di Dino—seem also not to have been poor. They ran a hotel in the upper Mugello, the valley of the Sieve, which, not far from San Giovanni, flows into the Arno. His father's family were *cassai*, or wooden-chest makers. Since such chests were often used to commemorate festive moments, they were sometimes painted. It's not unlikely that Masaccio had his first jobs as a *garzone*, or apprentice, in his grandfather's shop.

Masaccio had one brother, Vittorio, five years his junior, and born after the death of their father. The baby was also called Giovanni, and eventually became a painter known as Lo Scheggia—although not one of any great distinction. Masaccio may also have had a sister, born between himself and his brother.

The premature death of Monna Jacopa's husband, who died at much the same young age Masaccio was to die—about twenty-six years old—more or less forced her to remarry. Young widows could easily be considered threatening to a society as clearly and Christianly ordered as was late medieval society in Italy. And although Masaccio's mother probably had been able to count on her own family as well as that of her dead husband, and would in theory eventually have had her dowry returned to her, Masaccio's father would have left little enough with which to bring up a family of two or even three children. Monna Jacopa may, of course, also have remarried simply because she didn't want to live alone, or because she liked the new man. We have no idea what Monna Jacopa looked like, but since the Madonna in the San Giovenale triptych, probably painted when Francis was about 20, and in the painting reproduced in *cat. A13* seem to be the same woman, perhaps this is her.

In any case, she remarried a man much older than herself, already a widower twice, Tedesco del Maestro Feo, a wealthy druggist in San Giovanni. Perhaps it was he who ministered to her ill husband? He was over sixty, she about thirty. Toward the end of their marriage, Monna Jacopa became pregnant. She produced the male heir Tedesco had always wanted, but only after her second husband's death. The poor little half-brother to Masaccio and Lo Scheggia only survived a few months, perhaps helped on his journey to the next world by Tedesco's family, who were disinherited while the baby was alive.

The children of the dead *notaio* Ser Giovanni—Tommaso, Giovanni, and perhaps a sister—were brought up *pupilli*, that is, as wards of the court. We know a little about Monna Jacopa, and about her second family, but we know virtually nothing about Masaccio's childhood and adolescence, nor about his training.

Masaccio probably spent his childhood in and around San Giovanni. He may even have trained as a painter there, or in Arezzo, a large town also in the Arno valley, which Florence came to own, to the southeast of San Giovanni. There is no indication that either happened, but they are possibilities. It is more likely that Masaccio was eventually sent to Florence, perhaps by the time he was ten years old. It would have been normal for him to have begun training at eight or nine, and to have spent three or four years as a shop-boy before beginning officially as an apprentice. The apprenticeship would probably have lasted until he was sixteen or eighteen years old. Of course, the lad would have been precocious, more able naturally than his master in painting—not unlike the lad Mozart in music. So the course his youth followed may have been unusual. By the time he finished his apprenticeship, he would have been ready to join the painters' guild, the Arte de' Medici e Speziali, the doctors' and herbalists' guild, for it was the herbalists, or druggists, who dealt in pigments. Various painters' names have been put forward as possible masters to Masaccio: Mariotto di Cristofano, who came to marry one of Masaccio's stepsisters, although this happened after Masaccio was an adult; Francesco di Antonio, who came from San Giovanni; Bicci di Lorenzo, a painter who had a very active shop in Florence by the teens of the fifteenth century; and Giovanni del Biondo. But Masaccio's painting is so novel that it seems to relate in only minor ways to any of the painting in the Florentine world of his growing up. In fact, for some so far unexplained reason, Masaccio's work, in its feeling for space, and particularly for light and chiaroscuro, sometimes seems closer to the traditions of the painters from the Marche, the so-called Marches, to the southeast of Florence, particularly the Salimbeni brothers, who have left us a frescoed oratory in Urbino, or to Arcangelo di Cola da Camerino, and to Gentile da Fabriano, the most prestigious painter working in Florence in the 1420s. Arcangelo's painting in particular, is sometimes so close to Masaccio's, as to be enigmatic. It is highly unlikely that Masaccio was sent to train in the Marche, but perhaps as a lad he came into contact either with a Marchigian master, or with Marchigian painting. Certainly, Masaccio's interest in space, in falling light, in modeling, in volume, and in chiaroscuro doesn't come from the prevailing international Gothic taste in Florentine painting in the first two decades of the fifteenth century. The one Florentine of those two decades who does show a strong interest in volume, modeling, and chiaroscuro is the minor painter Giovanni Toscani, and it may be that Masaccio was sent to train with him. Perhaps significantly, Toscani sometimes painted the Christ child nude, and often used Cufic characters punched into the halos of his pictures. It's even possible that a *Madonna and Child* of his (*cat A12*) was painted together with Masaccio.

The influence of Donatello and Brunelleschi upon Masaccio has been pointed out so often, and to such a degree, that one is sometimes led to the ridiculous position of wondering if Masaccio is at all original: all his architecture stems from Brunelleschi, and all his figures from Donatello. Of course, Masaccio was a painter making pictures, and making them in a brand-new mode that imitated the space, the light, and the natural world around us, a mode in which the use of color to indicate hollowness or emptiness, or air, or light was as positive as its use to indicate figures or clothing or buildings. This was a mode of painting that in only six years Masaccio the painter developed to such a degree that it is arguable that he was the most influential painter who ever lived. There's no doubt at all that Brunelleschi and Donatello were enormously supportive of what Masaccio was developing, and they no doubt contributed to the painter's work. But to suggest that Masaccio wasn't

one of the greatest innovators—perhaps the greatest—in the history of European painting, is to overstate their influence.

Here is a list of the few contemporary documentary references to Masaccio that we have. They tell us a little about his life.

1418: Masaccio appeared as a guarantor in a document of the Arte dei Legnaioli, for a woodworker from San Giovanni.

1422: Masaccio joined the Arte de' Medici e Speziali on 7 January 1422, when he was twenty years old.

1422: 6 October: Masaccio made a payment toward his dues at the Arte de' Medici e Speziali.

1422: He would probably have been present at the consecration of Santa Maria del Carmine on 19 April, for at some later date he painted the monochrome fresco of the event to which Vasari refers, with many portraits of those who presumably were present.

1422: 23 April: this is the date written on the base of the triptych from San Giovenale di Cascia, near Reggello. It suggests that Masaccio was an established painter able to accept commissions even before his registration in the Arte de' Medici e Speziali. Presumably, the date indicates when the picture was finished; it would have been commissioned many months before.

1423: It has been suggested that sometime in 1423 Masaccio would have gone to Rome to be present at the *Giubileo* celebrations that year. He may well have gone earlier or later. Rome is roughly two hundred kilometers from San Giovanni—a week's walk, or considerably less by horseback or carriage.

1424: He joined the Compagnia di San Luca in Florence, a fraternity of painters.

1425: On 18 July, there is mention of a *Maso dipintore* as having a debt to Bartolomeo di Lorenzo, *pizzicagnolo*.

1426: There exist nine references to Masaccio and to the Pisa polyptych he painted between 19 February and 26 December.

1426: On 23 August, Masaccio is sued in Florence in the Mercanzia, for a small unpaid debt.

1427: On 23 January, Masaccio is witness to a notarial act at Pisa, for his patron of the Pisa polyptych, Ser Giuliano di Colino degli Scarsi da San Giusto.

1427: (just after) 29 July: Masaccio's tax return for the newly instituted *Catasto* (an income tax); he has significant debts. His name is lined out, and a note has been made in the margin: *dicesi è morto a Roma*—"said to have died in Rome."

That Masaccio died in 1428, at the age of twenty-six, is confirmed not only by Giorgio Vasari, writing in the middle of the sixteenth century, but also by Cristoforo Landino in 1481, as well as in two early codices, the so-called *Codex Magliabecchiano* and the *Codex Petrei*, where it is stated that the painter may have been poisoned. The fact that Vasari repeats this belief suggests that it was a long-standing rumor. What no one writes is who might have poisoned him, or why.

Almost everything else we know of Masaccio comes to us through the surviving works—the ones that most critics agree are by him. And these probably raise as many questions as they answer. There has never, for instance, been any agreement on the date or the

dates of the Brancacci Chapel, or why both Masaccio and Masolino abandoned it unfinished. Nor is there any evidence of why Masolino and Masaccio would have collaborated there and elsewhere, considering how different their work is. Nor is there any agreed date for the *Trinity*, for the panel by Masaccio from the *Santa Maria Maggiore* altarpiece, or for the *Sant'Anna Metterza* panel from Sant'Ambrogio. And although most critics agree on there being six extant commissions or parts of commissions by his hand, there are other works upon which there is no firm agreement at all.

Masaccio's working life lasted roughly six years, from the San Giovenale triptych of 1422, to his death in Rome sometime in 1428. He was away from Florence throughout most of 1426, in Pisa, and he would have gone to Rome earlier—perhaps on more than one occasion—to study ancient buildings and sculptures, perhaps with Donatello or Brunelleschi. Otherwise, most of these few years would have been spent in Florence.

Vasari names fifteen works by Masaccio, only six of which seem to have survived, but including two in Rome, the chapel in San Clemente and an altarpiece that was once in the basilica of Santa Maria Maggiore. Both these works also raise many questions for us, especially as the chapel in San Clemente seems, at least at this moment in time, clearly by Masolino. The six generally agreed-upon commissions are:

1) The *San Giovenale* triptych, of 1422.
2) The *Sant'Anna Metterza* panel, of about 1424.
3) Six scenes in the Brancacci Chapel, of 1425–28.
4) Various extant panels from the Pisa polyptych, of 1426.
5) The *Trinity*, of 1427–28.
6) The panel of *Saints Jerome and John the Baptist* from the S. Maria Maggiore altarpiece, of ? 1427–28.

The earliest of these is unquestionably the *San Giovenale* painting, which is dated 1422, when Masaccio was twenty. Although there are as yet no clearly cast shadows in this painting, it shows us already that Masaccio has understood and used one-point linear perspective. The floor lines, when extended, come together at a point just below the chin of the Madonna, while the throne and angels are also fit into this apparently receding pattern. Chiaroscuro is used forcefully in this painting so that the modeling, particularly of the Madonna and the nude infant, is almost sculptural.

The *Sant'Anna Metterza* painting, from Sant'Ambrogio in Florence, now in the Uffizi, is normally dated about 1424, that is, sometime between the two dated works, the *San Giovenale* picture of 1422, and the Pisa polyptych of 1426. It was recognized some time ago that this work is by both Masolino and Masaccio, and most critics agree that the Madonna and Child, the throne, and the middle angel on the right are by Masaccio, and the rest by Masolino. In this picture, Masaccio shows that his understanding of the unifying force of light has developed enormously. The light falls from outside the picture, and to the left, clearly modeling the mother and child on their throne. What is strange, if we accept that the whole picture was painted by two hands at one moment, is how differently the light strikes Masolino's angels, and Saint Anne. It's as though Masolino tried—sometime after Masaccio had finished his part—to fit his figures into the already existing light, but was unable to give them the vitality and truth that Masaccio imparts through a single unifying light falling on the Madonna and Child. Of course, there is also the possibility that the picture was left unfinished by Masaccio, and only later completed by Masolino, perhaps after Masaccio's death.

There is also a new sense of the heroic in this painting: the Madonna has the solidity and volume of Giotto's monumental figures, while the Christ child seems to be modeled from an antique model.

The date or dates of the Brancacci Chapel in the large church of Santa Maria del Carmine, in Florence, are an enigma. The chapel appears originally in the testament of Pietro di Piuvichese Brancacci in 1367. But nothing much was done until twenty years later, when work on the chapel began. This lasted, in turn, until after the dedication of the whole church in 1422—after which the decoration of the chapel did begin. Both Masolino and Masaccio worked there. But Masolino cannot have remained, if the sources are correct, after the beginning of September 1425, nor returned before mid-1427. In that period, he was away in Hungary working for the Florentine *condottiere* Pippo Spano. Masaccio must also have been absent throughout most of 1426, when he was in Pisa, so is unlikely to have done much work in the chapel in that period.

And yet such a large project would have taken considerable planning and preparation, as well as many months for fresco painting, and for final touching up, *al secco*. The most plausible explanation at the moment seems to be that the cycle was begun by Masolino in about 1424, when he would have executed the vault decoration. Masolino would have worked until sometime in 1425, when the pressures of his approaching journey would have forced him to stop. Masaccio would have begun, certainly by sometime in 1425, to have helped Masolino, and would have continued to work after Masolino's departure at the beginning of September 1425. Masaccio may well have gone on sporadically doing work, or at least planning work in the chapel during 1426: at one point, his patron in Pisa made him promise not to do other work until the Pisan picture was finished, indicating that Masaccio was, in fact, contemporaneously engaged in other projects. Masaccio would have returned to work in the chapel anyway, after he left Pisa in about February 1427, and would have had time to work there until his departure for Rome sometime in 1428. Of course, it's probable that this last period is when Masaccio painted the *Trinity*, so his time for Brancacci's chapel would have been limited. Certainly, he wouldn't have ever returned to the chapel after his final departure for Rome.

Regardless of the precise dates, Masaccio's work in the Brancacci Chapel is the cornerstone of the whole development of Western painting over the next 450 years. The depiction of man in nature is so monumental in its conception , and so limpidly clear that most subsequent European painting eventually develops three themes found there: landscape, portraiture, and still life. Masaccio paints nature as something real—in fact, as *the* reality of life, something of great interest and value, with man as an integral, and even dominant, part of it. In fact, he goes a step further, because he makes all nature's logic and reality centered in man's vision of it. This is a complete break from medieval thought, when both nature and man are things of little consideration, in comparison to the true heavenly and spiritual order of things. Masaccio's reorientation of nature and man indicates, of course, the roots of the modern world in the scientific investigation of nature.

There are six frescoes in the chapel that were painted by Masaccio: the *Expulsion*, the *Tribute Money*, the *Resurrection of the Son of Theophilus and Saint Peter in Cattedra* (finished by Filippino Lippi later), the *Baptism of the Neophytes*, *Saint Peter Healing with His Shadow*, and the *Distribution of the Goods of the Community and the Death of Ananias.* The buildings in the background of the *Healing of the Cripple,* by Masolino, also seem to be by Masaccio.

There are also three frescoes by Masolino: *Adam and Eve in the Garden*, the *Healing of the Cripple and the Resurrection of Tabita* (with houses behind by Masaccio), and *Saint Peter Preaching*.

And then there are a further four scenes by Filippino Lippi painted in the mid-1480s, when Filippino would have been in his late twenties, as well as the completion, as noted above, of the *Resurrection of the Son of Theophilus*, on the lower register of the left wall. These are two small scenes on either side of the lower level of the chapel's entrance pilaster, *Saint Paul Visits Saint Peter in Prison*, and the *Liberation of Saint Peter from Prison by an Angel*; and two larger scenes on the lower right-hand wall, probably left unpainted by Masaccio and Masolino, but perhaps with sinopias drawn out upon the wall: the *Dispute with Simon Magus before Nero*, and the *Crucifixion of Saint Peter*.

In the chapel, there are also some recently discovered decorative fragments around the window frame, including two heads that seem to be by Masolino (*cat. 3*), although the right-hand head may be by Masaccio imitating the manner of Masolino.

Originally, there were scenes painted on the ceiling of the chapel—its vault surfaces, and the three lunettes—but these were destroyed in a remodeling of the chapel in the 1740s. Parts of the sinopias of these scenes have survived. There were apparently illustrations of the *Calling of Saint Peter, Saint Peter Walking on the Waters, Saint Peter Having Denied Christ*, and *Christ Ordering Saint Peter to Care for His Flock*.

Of the paintings on the side and back walls of the chapel, almost certainly the two scenes on the upper level, above and to the sides of the altar, were the first to be painted, once the ceiling was finished. Frescoes were normally painted from left to right (for a right-handed painter) and from the top downward. This procedure is dictated by a need to see clearly the sinopia, and what's already been painted, and by gravity. Those two scenes, *Saint Peter Preaching*, by Masolino, and the *Baptism of the Neophytes*, by Masaccio, both have a crowded quality that doesn't exist in the other scenes on the upper register, suggesting that they would have been done first.

Then probably Masaccio did the whole left upper register wall (the *Tribute Money*) and entrance pilaster (the *Expulsion*), while Masolino worked opposite, on the right upper register (*Adam and Eve in the Garden*, and the *Healing of the Cripple and the Resurrection of Tabita*). The painting of the buildings in the background of Masolino's fresco, as noted above, is of such illusionistic competence that it was almost certainly, for whatever reason, done by Masaccio. It is, of course, vaguely possible that Masaccio was originally hired to help Masolino: so Masaccio did the houses behind the *Healing of the Cripple*; then Masolino left, and Masaccio went on with the frescoes still to be painted. But this scenario seems unlikely.

Masaccio's two paintings on the upper part of the wall, the *Expulsion*, and the *Tribute Money*, have, since their cleaning in the 1980s, lost much of their sense of drama, and with that their feeling of being sacred Christian decoration meant to sanctify an area used for the Mass. All the shadows have been considerably lightened, weakening the strength of the most dramatic passages and diffusing the power of the images. The colors, too, seem watered down. And whereas it is now possible to see things in the background that were not clear before, particularly in the *Tribute Money*, this shift of focus has also meant that the incidental, narrative quality of the pictures has come to dominate the dramatic, artistic one. In the *Expulsion*, for example, one is now as conscious of the gate behind Adam and Eve, or of the space between Adam's legs, as of their agony: but the agony should dominate, of course,

as that's what the picture is about. It's not about the gate behind them. The paintings are flattened out now and look more like color photographs, where the various elements have fairly equal values. Besides, Masaccio would have used *secco* techniques to hide the obvious seams where the fresco *giornate* come together. The seams are now painfully clear.

This washed-out quality in the colors exists throughout the chapel, but is particularly unfortunate in the *Expulsion* and in the *Tribute Money*. Another of the results of this flattening of the dramatic, sculptural quality in Masaccio's work is to make the differences between Masaccio's and Masolino's paintings less evident, a result the restorers themselves have remarked upon, noting that Masolino seems a stronger painter since the restoration. No one, in the whole history of art, particularly no artist, ever before saw the frescoes of Masolino as being nearly as powerful as those of Masaccio. The situation after the restoration, particularly for many, and particularly for many artists who visited the chapel both before and after the restoration, was summed up by one art teacher in Florence, who remarked succinctly: "If that was only dirt they took off those walls, some of it was the most intelligent dirt that ever fell on a wall anywhere."

By the time that Masaccio moved the scaffolding down from the upper level to work on the *Resurrection of the Son of Theophilus*, and *Saint Peter in Cattedra*, Masolino was certainly gone from the chapel forever. Nor did Masaccio stay much longer: for some reason, this lower fresco was either left unfinished, or was finished, but then defaced in such a way as to leave the whole central section to be completed by Filippino Lippi many years later. Filippino Lippi also painted the entire lower register of the right-hand wall, under Masolino's fresco of the *Healing of the Cripple and the Resurrection of Tabita*. It is possible that the sinopias for the two main scenes there, *The Dispute with Simon Magus before Nero* and *The Crucifixion of Saint Peter* had already been drawn out upon the wall when Filippino started to paint: both these scenes appear as part of the life of Saint Peter at San Piero a Grado, the only other extant Tuscan cycle of pictures dedicated to the life of Saint Peter, which predates the Brancacci Chapel.

As far as the development of Masaccio's painting is concerned, the Brancacci Chapel becomes the temple of art to which painters tread a path for centuries. Vasari lists most of the great Renaissance artists to his day as having been to the chapel to study. He then points out that there "where great artists flock so do the lesser." Not only is the development of one-point linear perspective perfected in each of Masaccio's scenes in the chapel; Masaccio even attempts to join scenes in a common perspective system, as though together they had a real common space. The chapel itself is treated like a large open pergola with the spectator looking out through openings to the scenes painted as though all part of a single imaginary world.

Masaccio manages to make his figures not only real, but of a statuesque solidity, struck by a powerful, dramatic light that seems to come streaming in the single window of the chapel. These figures he places in a world like the one he knew around him, a country world full of nature stretching off to distant mountains like those of the Pratomagno at San Giovanni Valdarno, or the contemporary Florentine urban world. His men are no longer the religious figures of a Christian hierarchy, but have become already free-willed, independent masters of the world around them.

The *Trinity* terminates the Middle Ages by summing up the most profound Christian medieval doctrine, the Redemption, in a modern and scientific form, measured by man-the-

spectator, who by the scale and reality that he brings from outside the picture into it, brings it logic and life. Masaccio renews Christianity by making the offering of Christ on the cross—through the physical linkage of Adam and Christ, but also through the essential spiritual presence of the spectator—us—an offering of us, by us, for us.

And in the *Tribute Money*, a vast open landscape dominated by a classical, free, and powerful man, who is again us, opens the Renaissance. In this light-filled landscape, Masaccio introduces the idea of freedom—man's freedom in an essentially good, natural world.

The Pisa polyptych of 1426 is the firmest date we have for Masaccio's painting. We know that the contract for the picture was signed on 19 February 1426, and that there were eight payments over the succeeding ten months—the final payment made when the picture was finished on 26 December 1426. Although the four main lateral saints have disappeared, we are fortunate to have the central section (albeit horribly overcleaned in the 19th century) with the *Madonna and Child* and four angels, as well as the three predella panels, and a very beautiful scene apparently from the apex of the altarpiece, *Christ on the Cross with Saint John the Baptist, Mary His Mother and the Magdalene.* From this polyptych, we also have six small figures of saints.

The Madonna herself in what was the central panel of the picture shows us that Masaccio is not just a master of light, mass, and space, but that he is able again to create, by using a view from below to give the figure even more strength, Madonnas in the grandiose manner of Giotto. He sets off the solidity and power of the Virgin by making the Christ child nude—thus, vulnerable—humbly sucking grapes, a symbol of his divinity. Two of the predella panels are done with great ingenuity, painted with such ease, with such an elegant understanding of man's commanding role in nature that nothing done in painting in all the thousand years from the fall of Rome to the early fifteenth century can compare favorably with the humanity in Masaccio's work, if not some contemporary work of the 1420s in Flanders. These scenes are the *Adoration of the Magi*, which Vasari remarks upon, and the *Martyrdoms of Saints Peter and Paul*. The third predella, of scenes from the lives of Saint Julian and Saint Nicholas, is certainly the work of an assistant to Masaccio.

Two other pictures are all that remain of the sure work of this young genius who died at age twenty-six: the *Trinity* fresco in Santa Maria Novella—easily one of the most influential paintings ever made; and the single panel of *Saint Jerome and Saint John the Baptist,* which Masaccio must have done for the Santa Maria Maggiore triptych before he died in Rome in 1428.

The *Trinity* has been harshly treated over the centuries, and shows it. In the mid-sixteenth century, a large altar was constructed against it, covering it completely. When it was rediscovered in the last century, the whole piece of wall on which the triumphal arch was painted was moved down the church to be attached to the wall near the main entrance. In the middle of this century, the picture was brought back to the original position and rejoined with its lower portion, the monochrome sarcophagus with a skeleton lying on it.

The *Trinity* is, above all, a deeply religious painting. It was painted in the Dominican church of Santa Maria Novella. Not only are the Dominicans traditionally the philosophers and theologians of the Church, but they have acted for centuries as watchdogs against heresy. Although known as the *Trinity*, it is as much a painting of the Resurrection and Redemption as a picture of the Trinity. It seems to have been painted to celebrate the feast of *Corpus Domini*, the truth in Christianity through which during the Mass, the bread and wine

become miraculously the actual Body and Blood of Christ. It was probably painted in 1426 or 1427, but may have even been painted in 1428, before Masaccio left for Rome.

The painting's meaning begins at ground level where there is a tomb inscribed: *IO FU GA QUEL CHE VOI SETE: E QUEL CHI SON VOI ACO SARETE*—"I was that which you are, and what I am you will be." So the reference is to us, to Everyman. But Christ's cross grows, so to speak, above this tomb. And so there is a reference also to the legend that the cross used in Christ's crucifixion was made from a tree that grew from Adam's body—the Redemption would refer back directly to Adam's sin.

Above, in what appears to be a mortuary chamber, Christ's dead body, still on the cross, is held up as an offering by God the Father. Mary, at the foot of the cross, symbolizes the Church, and she indicates the body of Christ as our salvation. The principal figure in this revolutionary composition—toward whom all is oriented—isn't the Trinity, as it would have been in medieval thought, nor Mary (the Church), nor Saint John (mankind), nor even the donors just outside the great arch. The principal figure is us—the spectator, the ordinary passerby—who stands before and apparently outside the composition, but without whom the whole imaginary structure has no meaning, physically or spiritually: all the complex perspective construction emanates from an imaginary point where we stand, a few feet in front of the painting.

In the *Tribute Money*, Masaccio placed man as the center of the natural world, for whom God has made everything. Here in the *Trinity*, Masaccio places man in the center of the spiritual world of Christianity, without whom the Crucifixion, the Resurrection, and the Redemption have no meaning. We—Everyman, Mr. Anybody—not only are dead under the altar upon which Christ's body is reborn in each mass, waiting for the Redemption, but we stand living, and part of, the greatest truth of Christianity.

And Masaccio paints this renewed truth into a symbol of the rebirth of the classical world, a magnificent Roman building, with coffered ceiling, great triumphal entrance, and the wall pierced as though we could all truly step into the mysterious world of the Christian Trinity. This is indeed the renewal of Christianity, the new Jerusalem, for which so many Florentines in the early fifteenth century hoped.

The last generally accepted work by Masaccio is a single panel, now in London's National Gallery, of *Saints Jerome and John the Baptist*. This panel was once part of a triptych painted on both sides, apparently for a chapel in the big Roman basilica of Santa Maria Maggiore. All the other five panels were painted by Masolino. Presumably, either Masaccio and Masolino were commissioned to do the picture together, perhaps one side each, or Masaccio was commissioned the work but died before he could do more than one panel. The church was under the patronage of Cardinal Branda Castiglione, and contained a chapel belonging to the Colonna family, the family of the then-pope Martin V, whose portrait appears in the painting. The picture was certainly commissioned by one of these high prelates and must have been for the Colonna chapel.

Of the various other works that one or another critic feels may be in part by Masaccio, there are three that seem to have more claim to be by his hand.

The first is a *desco da parto*, now in Berlin. This scene, in an excellent perspective arrangement of columns of the celebrations after the birth of a child, is of such high quality that—if the panel indeed dates from the 1420s—no one but Masaccio could have painted it. If

it dates from about 1440, as has also been maintained, it would obviously have to be by another artist. But in that case, the question of who painted it remains a difficult one.

The so-called Casini Madonna—after the name of the Cardinal whose coat of arms is found on the reverse—is a strange picture. It has an unquestionable Masaccesque quality. But its stiffness, together with the crude way all the hands are bunched together, and a general rigidity in the painting, makes it hard to attribute convincingly to Masaccio, unless he was hardly a lad at the time it was painted. Of course, so much of Masaccio's work has been mistreated by restorers that this picture may also have suffered from touches of repainting.

The third of the paintings that seem to have a valid claim to have been worked upon—in one way or another—by Masaccio is the chapel frescoed by Masolino in the Church of San Clemente in Rome. There are certain elements both in the chapel, and in the *Annunciation* on its exterior arch, that seem too sophisticated to have been attempted by Masolino without some sort of help from Masaccio. In particular, the landscape of the *Crucifixion*, and the *sinopia* for it, could hardly have been drawn by Masolino without help. The manner in which Christ, in the *sinopia*, hangs almost weightless over the landscape, seems of an imagination and a spirituality quite foreign to Masolino's rather pious, often stilted figures. The drawing, too, of the mounted *cavaliere* to the lower left in the *Crucifixion* is also too-well-executed, especially in the *sinopia*, to be by Masolino, although it may be by an assistant such as Vecchietta, who helped Masolino in the 1430s with the decoration for Branda Castiglione, of the church and baptistery in Castiglione's native village north of Milano, Castiglione d'Olona.

The world that produced Masaccio was a late-Gothic world, a world of waning medieval Christianity, which he stepped beyond. Like Donatello, Nanni di Banco, Luca della Robbia, Jacopo della Quercia, and Brunelleschi, Masaccio completely detached himself, not at all from Christianity, but from the arid forms of Christianity that were all around. This spirit of Christianity had become atrophied in forms that had developed in the miserable years during and immediately after the Black Death of fifty years before. They had become perpetuated by the delusions of the vicious Florentine War of the Eight Saints against the papacy, and by its sequence, the *Great Schism*. Masaccio and his revolutionary colleagues realized instinctively that only by completely recasting Christianity in a new, natural, and man-oriented image, could Christian renewal take place.

They were helped by the events that almost brought an end to the Christian church's central organization, as it had been known for a thousand years. Between 1378 and 1417—that is, during the youth of both Masaccio's parents, and of himself—the papacy was in such disarray that Christendom found itself with first two popes, then with three: an Avignon pope, a Pisan pope, and a Roman pope. To illustrate how close Florence was to these events, it's enough to point out that the Pisan pope was a Florentine pope as well, since Pisa was then Florentine territory, and that this Pisan pope, who died in 1419, is buried in the Baptistery of Florence, in a solitary magnificent Renaissance tomb sculpted by Michelozzo and Donatello, and mostly paid for by the pope's banker, Cosimo Medici. That pope was called John XXIII. So deep were the Church's wounds then that recently a pope has again called himself John XXIII, no doubt in part to emphasize that the earlier Pisan-Florentine had never been, at least for the Papacy in Rome, a valid pope.

Finally, in 1417, at a church Council held in Constance, in southern Germany, these three popes were replaced with a fourth, Martin V, the Roman noble of the Colonna family

mentioned earlier. Unable because of the weakness of his claim to be pope, and of his position in general, to take up residence in Rome, this pope lived in Florence for some eighteen months in 1419 and 1420, in Santa Maria Novella—where Masaccio was to paint his *Trinity* only a few years later. Colonna's legitimacy continued to be contested by one of the ex-popes, by diverse churchmen and theologians all over Europe, as well as by supporters of the "council" theory (by which church councils were superior to popes) throughout the 1420s. The old medieval papacy had died during the Great Schism, while the new Renaissance papacy, based on temporal power and its effective use, had yet to be born. Europe had formed into new nation-states that came to control more and more their local Christian religious organizations, meaning that the unity of Christian Europe under one pope was gone forever. Italians dreamed, too, of the reunification of their peninsula into a single powerful nation, as it had been in Roman times. Florentines, in particular, felt the enormous economic, social, and cultural power of their city in the first quarter of the fifteenth century, when it survived various serious threats to its liberty while expanding its own domain to include important new territories such as Pisa and Arezzo. The scale of the vast fairly independent churches in Florence of the "poor" religious orders—mainly, the Carmelites, the Franciscans, the Dominicans, the Augustinians, and the Servites—also suggests that the Florentine church establishment was considerably independent of the papacy. From the early fourteenth century onward, right until after the time of Machiavelli two hundred years later, Italians wrote about this goal of a resurrected, united Italy. Of course, the papacy knew that a united Italy meant the end of papal independence, and so the various popes, from Martin V onward, always resisted it.

Against this background, it would not be surprising to find that Masaccio's frescoes in the Brancacci Chapel have a fairly strong political character, and various critics have suggested diverse interpretations of a political nature to the frescoes.

The Church, in the person of Saint Peter, is shown preaching, baptizing, healing, distributing alms, and working miracles. Saint Peter is shown unadorned, a simple poor follower and servant of a simple and poor Christ.

The message of the chapel's pictures would seem to be: after the *Temptation* and the *Fall* of Adam and Eve, depicted on the entrance pilasters, man's soul can be saved through the good works, the grace of the Church. But the Church is seen in Masaccio's frescoes as clearly limited also. In the *Tribute Money*, the Church is instructed by Christ to pay taxes, and thus give homage, to the state. This idea was the exact opposite of the claim by the Church throughout the fourteenth century, to be above any national rulers or laws. And in the *Resurrection of the Son of Theophilus* below, there is no question that the authority of the state must be enhanced by Christianity, not substituted. The simplicity with which Saint Peter sits in that painting *in cattedra*, without tiara, staff, keys, or any cloak of authority, surrounded by priests and artists, suggests that Masaccio (and perhaps Brancacci and the Carmelites as well)—using the poor art of fresco—wished a message describing a poor church to be conveyed in the chapel. The scene of *Saint Peter Resurrecting the Son of Theophilus* depicts the civil governor of Antioch on the left looking across to the church—Saint Peter—on the right, who, in turn, is praying to God. This may be a reference to how the papacy in the 1420s should help Italy to become resurrected once again as a single country, after its own long death. The opposition by many of Florence's most powerful commercial families to the Medici, and to their close ties to the papacy, would certainly have roots in this great desire to

see an Italy independent of papal temporal power. If the Brancacci Chapel is as antipapal as suggested here, this may be the reason for the persistent rumor that Masaccio was poisoned.

Of course, if Filippino Lippi—as seems likely—only painted what was already planned and sketched out in sinopia on the lower right-hand wall, then the message was to have been even more specific: simony—that is, the selling of church favors for cash—was one of the most prevalent and most criticized of church practices. Filippino's scene *Saint Peter and Simon Magus before Nero* is about simony—the word comes from Simon Magus. The scene of the martyrdom of Saint Peter also carried a heavy message for a rich and arrogant papacy: the Church should make its first duty the carrying out of Christ's will, even unto death.

These are certainly not messages the new pope, a powerful Roman intent upon his own personal power and upon restoring as much of the temporal power of the central papacy as he could, would have wanted to hear, especially from a Florence booming with a reforming spirit.

Masaccio's lasting effect on the history of Italian painting was enormous. He seems to have been the first person to have used scientific linear perspective in painting in such a logical way that it could be learned by anyone, and was. Immediately after his death, painters—in particular, Filippo Lippi, who had been a young novice in the religious community at the Carmine Church in Florence—began regularly to develop their pictures using linear perspective. This use of perspective to develop an illusion of space on a flat surface secularized space by making the space of the natural world both within the picture and without, more interesting than the heavenly space that had been dominant in painting until Masaccio's time. This natural space is then investigated in pictures in all its aspects until the invention of the photograph some four hundred years later, at which point painters became more interested in other formal elements of painting than the picturing, in one way or another, of things in the natural world.

Masaccio's use of color was also enormously innovative: the band of color made by the Apostles' cloaks across the front of the *Tribute Money* is not only the foremost dominant abstract element in the whole composition, giving a lightness, a vivacity, and a majesty to the picture, but the manner in which Masaccio uses the lighter and darker colors without contours to enhance the statuesque, and the illusion of space is new to painting. He shows that apparently empty space is a positive element in painting—even a concrete one.

Masaccio turned the Christ of the fourteenth century, a suffering symbolic Christ, into an ordinary human being. He does this both in the *Trinity*, where an anatomically correct Christ is placed triumphant on the cross, and in the Brancacci Chapel, where Christ is one of us—except that he and we have come together as one, the central point of the natural world. Christ's head is the vanishing point of Masaccio's perspective system in the *Tribute Money*. This is where our own world of nature, and the imaginary world that Masaccio invents, flow each other, the world of imagination and the world of reality overlapping, becoming each other—all one common space without barriers. Christ and we, so to speak, are both the center of reality. This is, of course, in keeping with the whole movement of humanism that was so strongly developing in Florence in precisely the years of Masaccio's working life.

Masaccio painted man the spectator—that is, the man outside the picture—into the picture. Because he made space and the picture in it a projection of our thoughts and especially of our memory, the picture became extremely political: Masaccio paints the past in a way

that he wishes it to be seen, but so realistically that it's as though things really happened as he depicts them, with us part of whatever happened. This obviously encompasses a secularization and personalization of religion.

Masaccio seems to have copied classical architecture and classical sculpture: the heads of the apostles in the *Tribute Money*, clad in their classical togas, may well have been copied from Roman busts. This brought painting to much the same point that sculpture and architecture had reached by the 1420s, where the imitation of the classical was already an established element in the renewal of architectural and sculptural forms.

Color Plates

**Madonna and Child Enthroned,
with Two Angels and Saints Bartholomew, Blaise,
Giovenale, and Anthony Abbot, 1422.**
Cascia di Reggello, Pieve di S. Pietro
[cat 1]

pages 26-28: [cat. 1] *details*

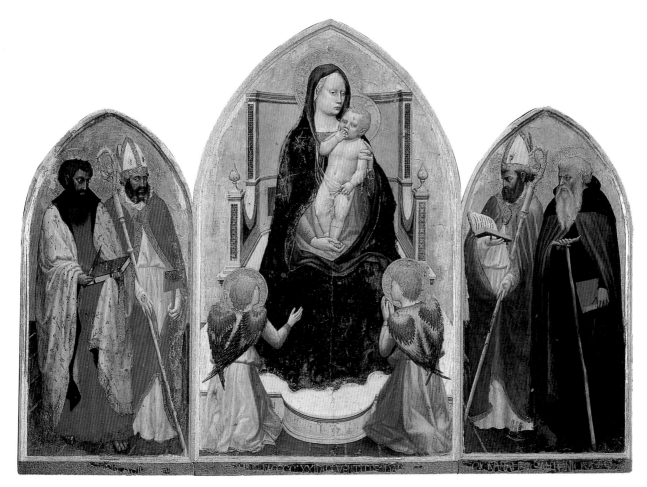

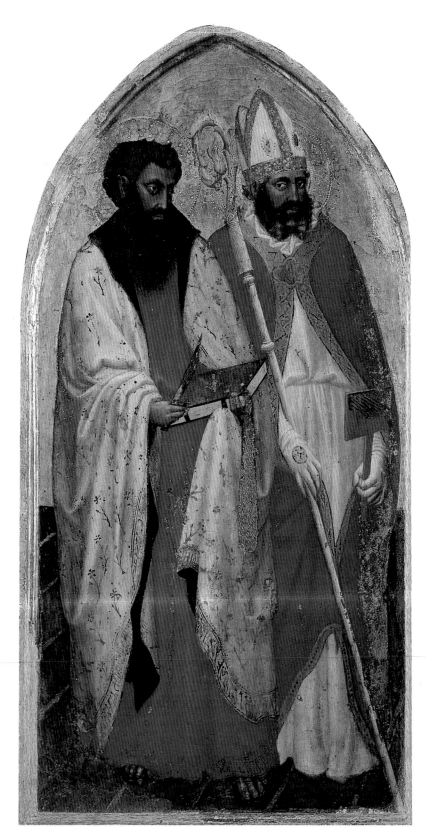

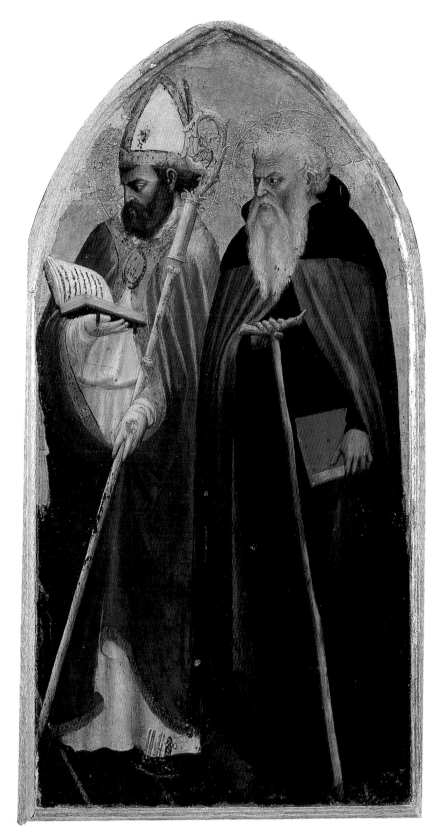

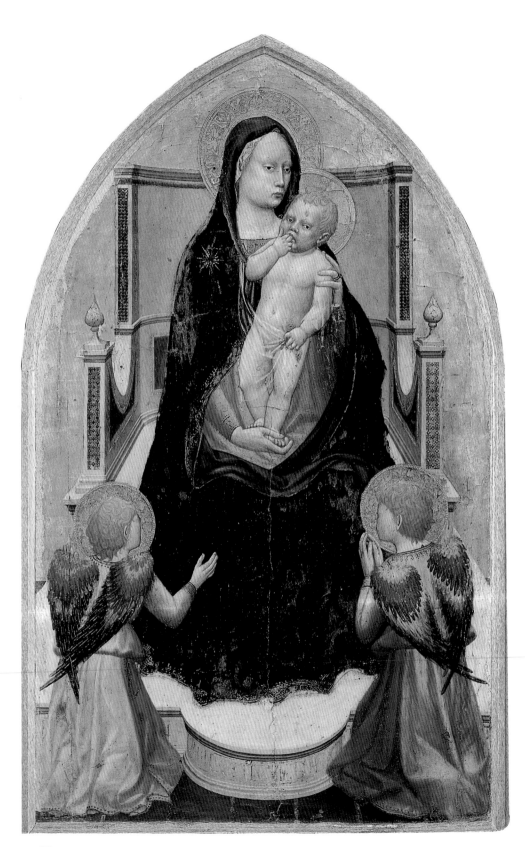

**Madonna and Child Enthroned,
with Saint Anne and Five Angels**
Florence, Uffizi
[cat. 2]

pages 30-32:
[cat. 2] *details*

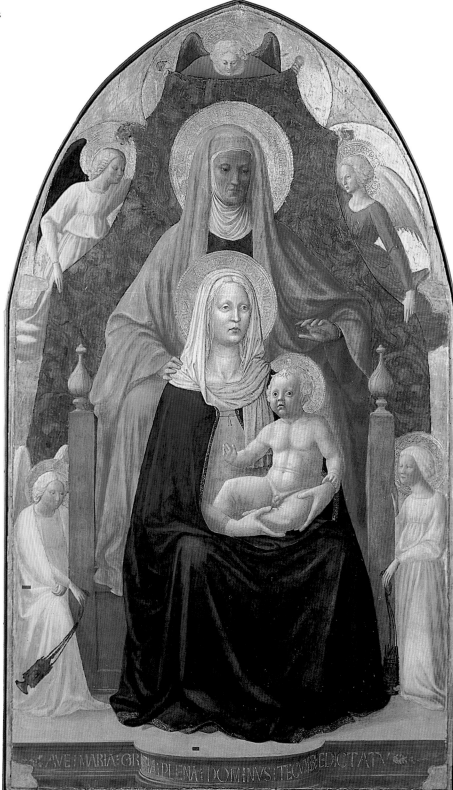

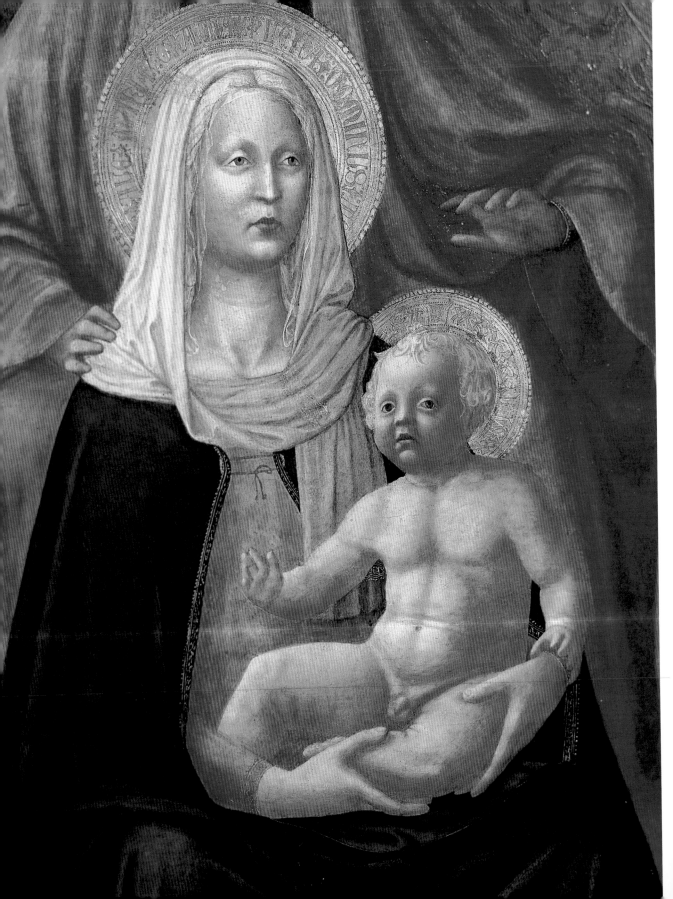

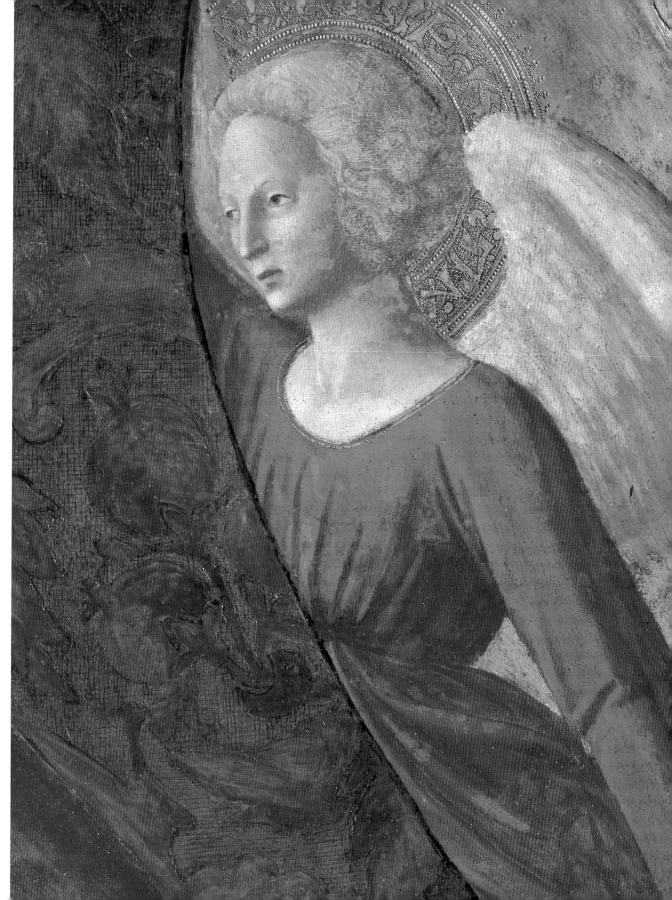

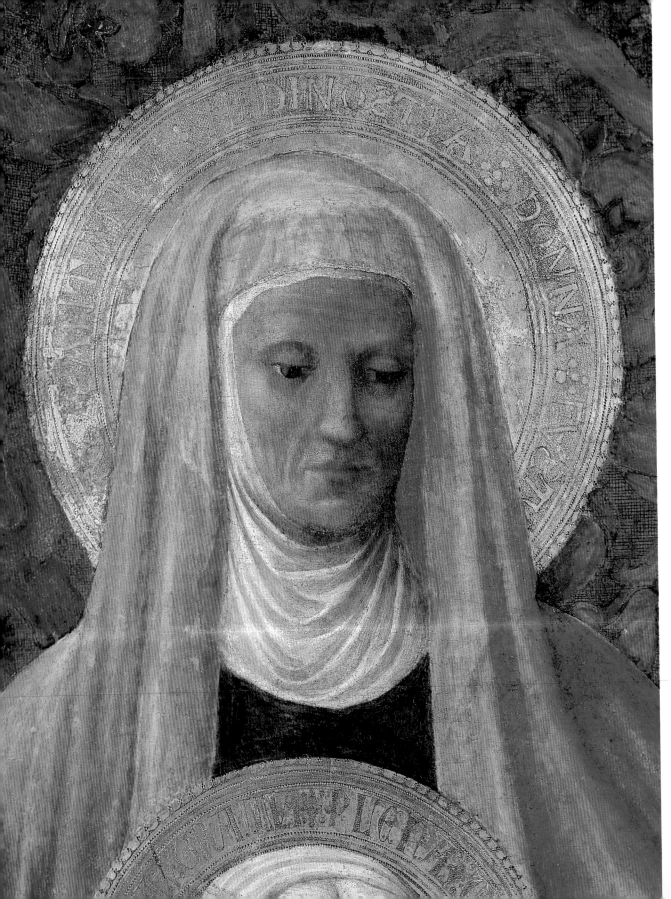

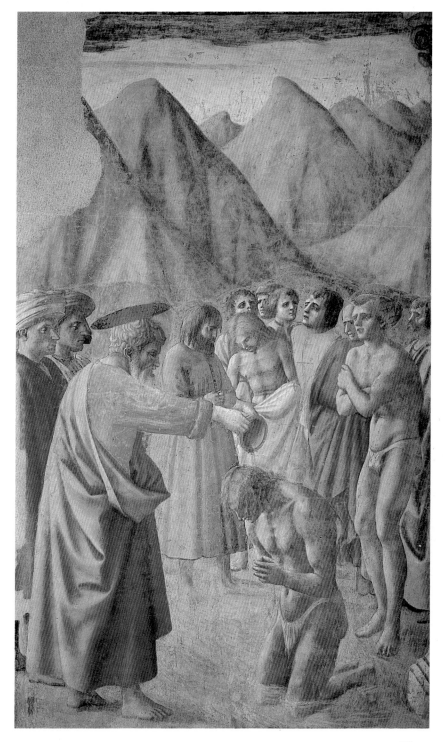

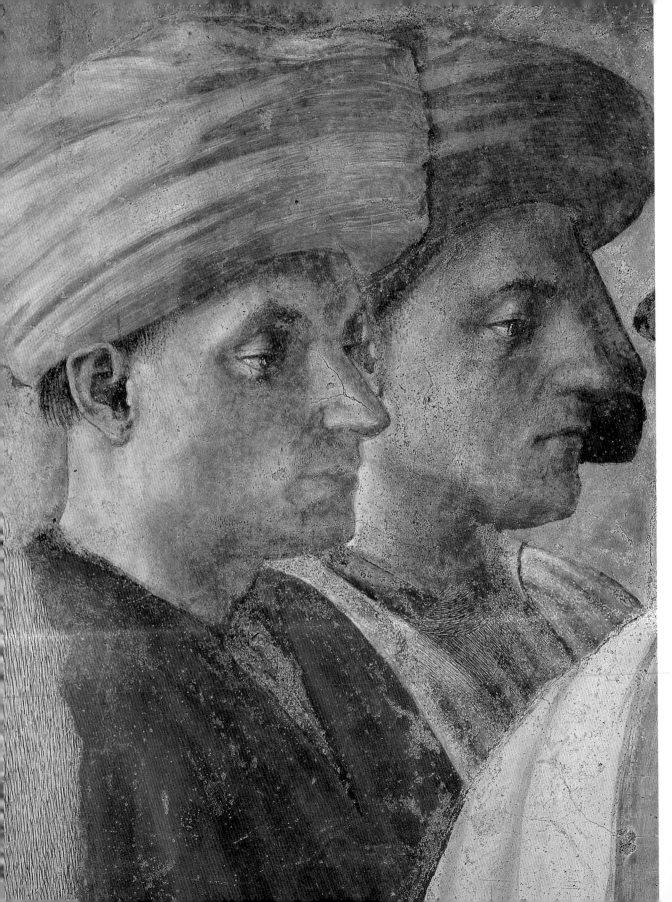

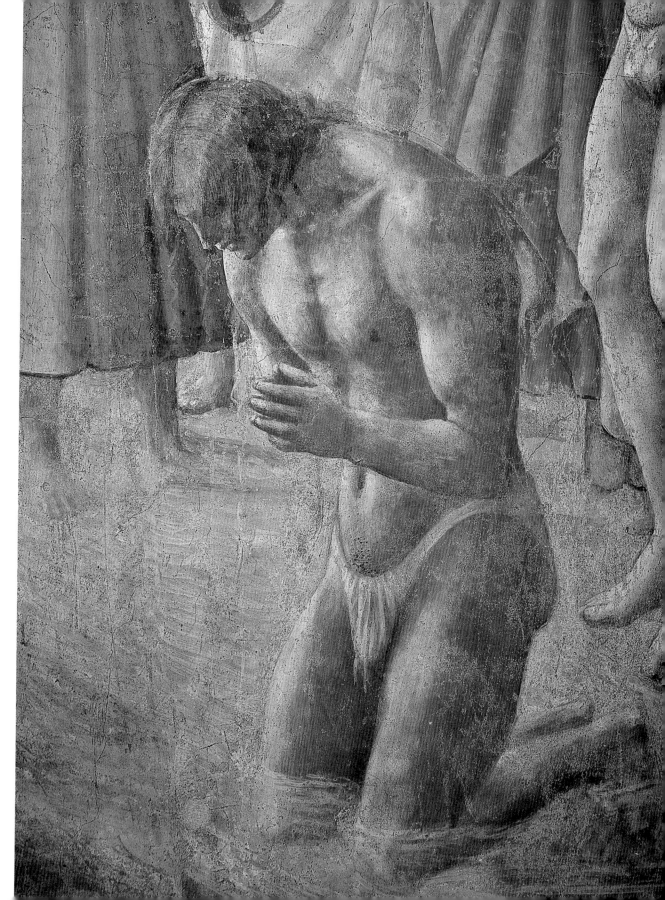

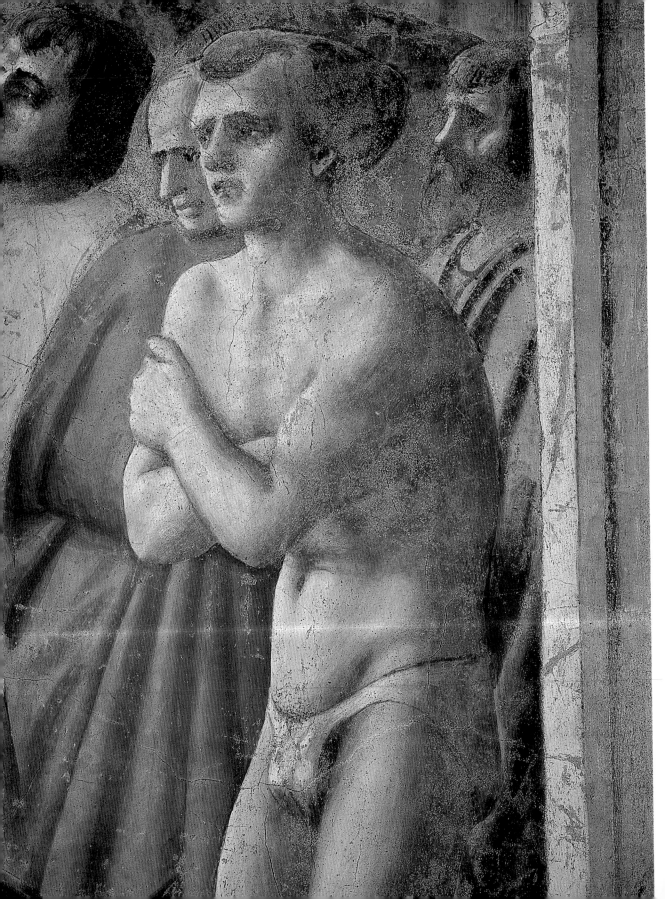

The Brancacci Chapel

The Expulsion
Santa Maria del Carmine, Florence
[cat. 3b]

pages 38-39: [cat. 3b] *details*

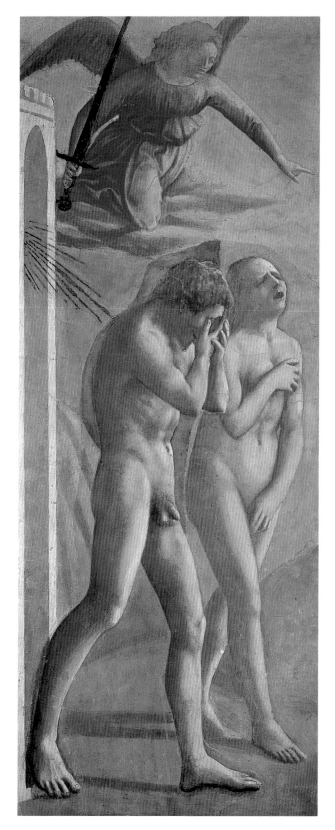

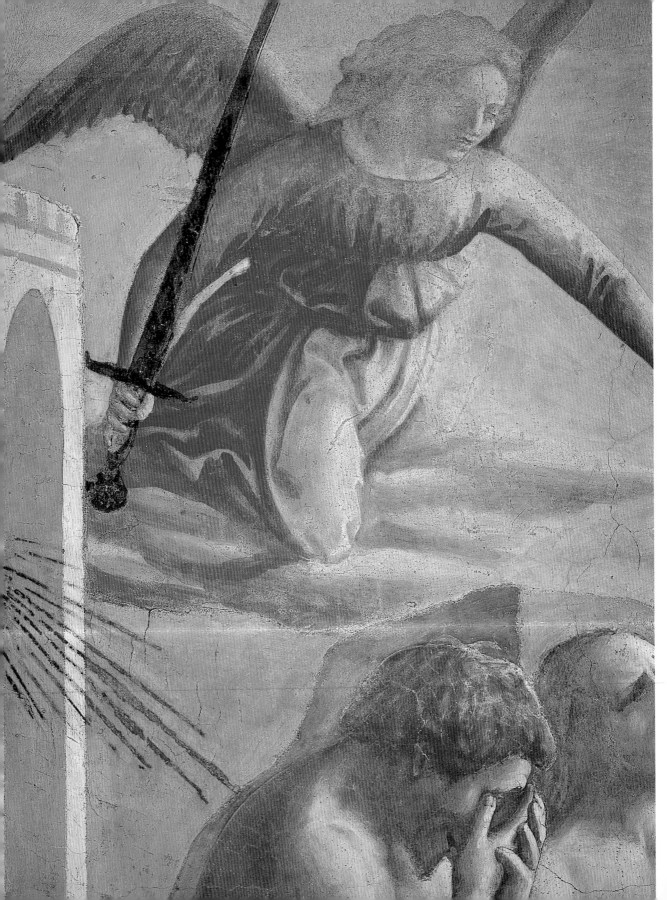

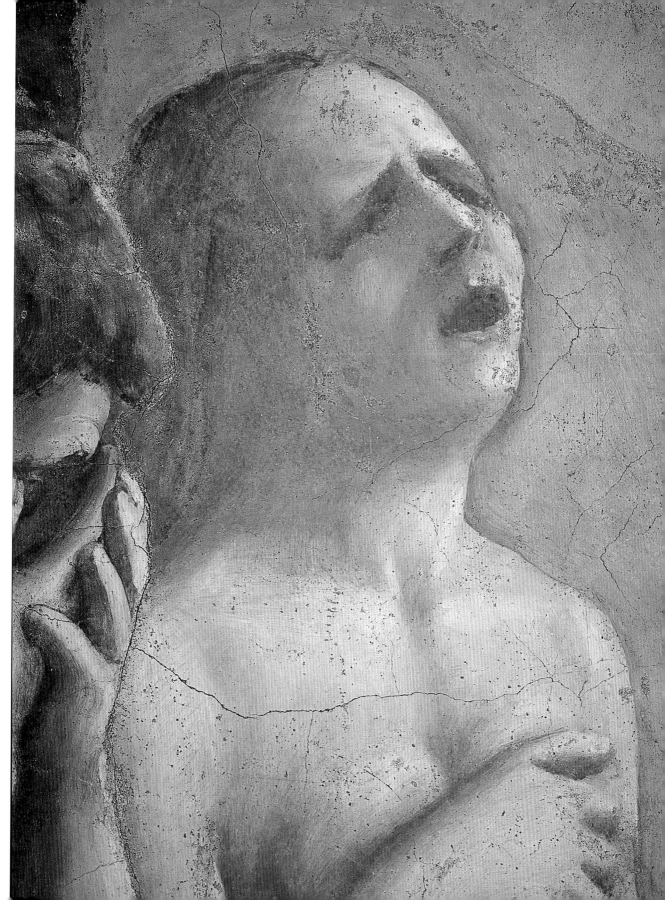

The Brancacci Chapel

The Tribute Money
Santa Maria del Carmine, Florence
[cat. 3c]

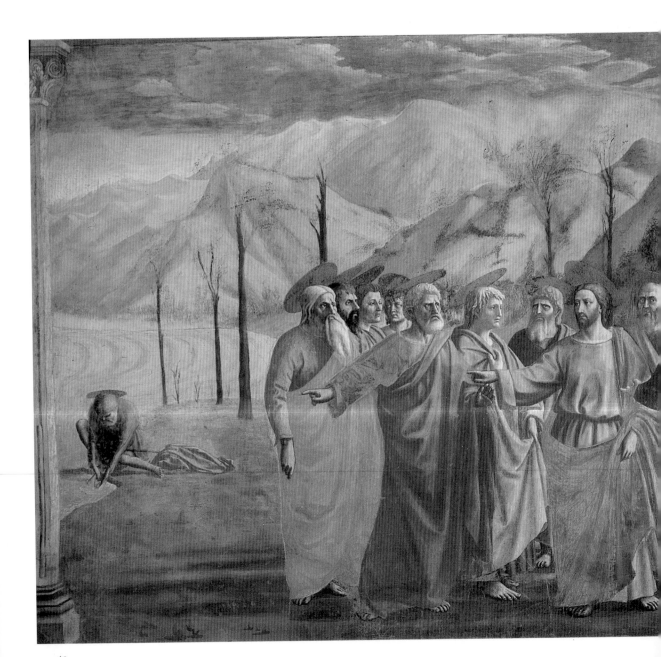

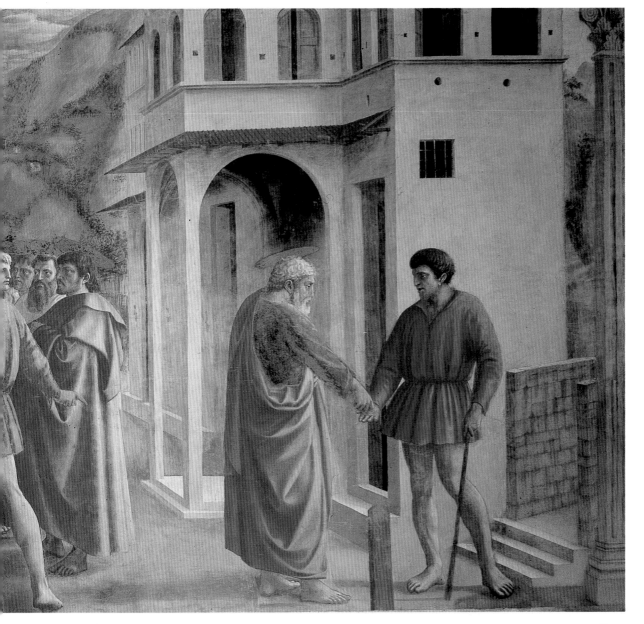

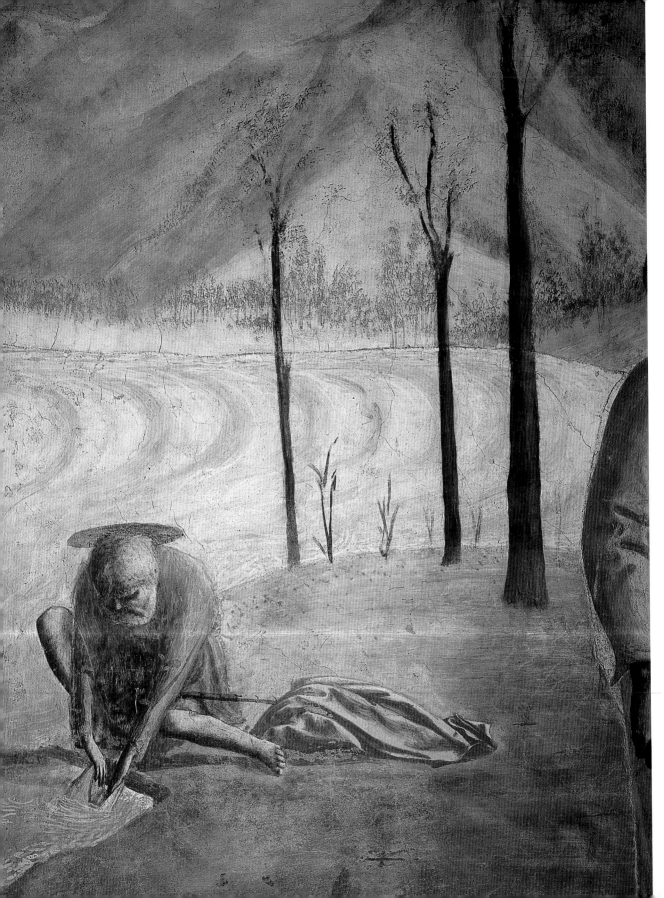

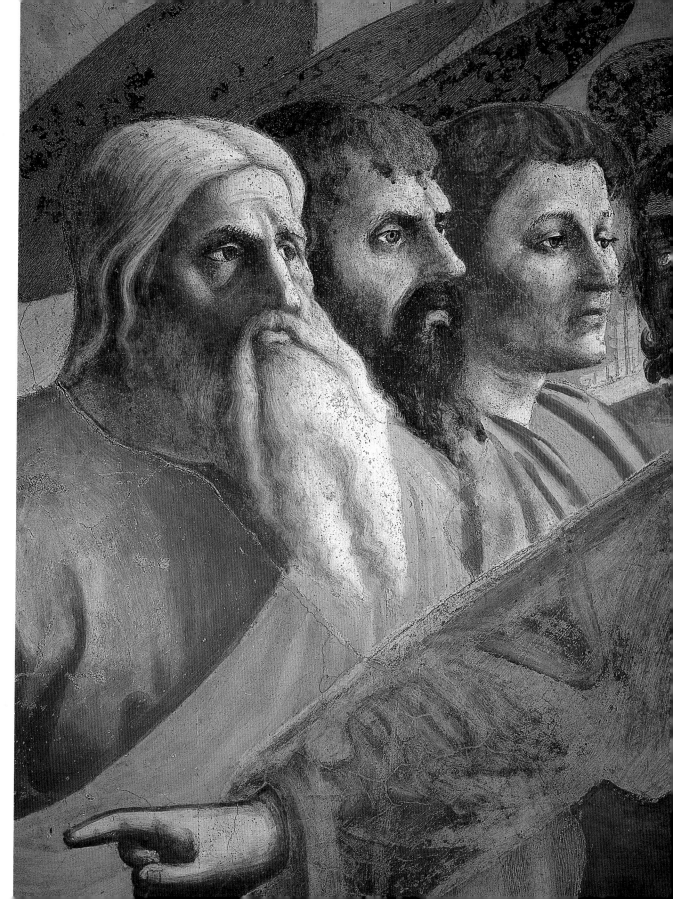

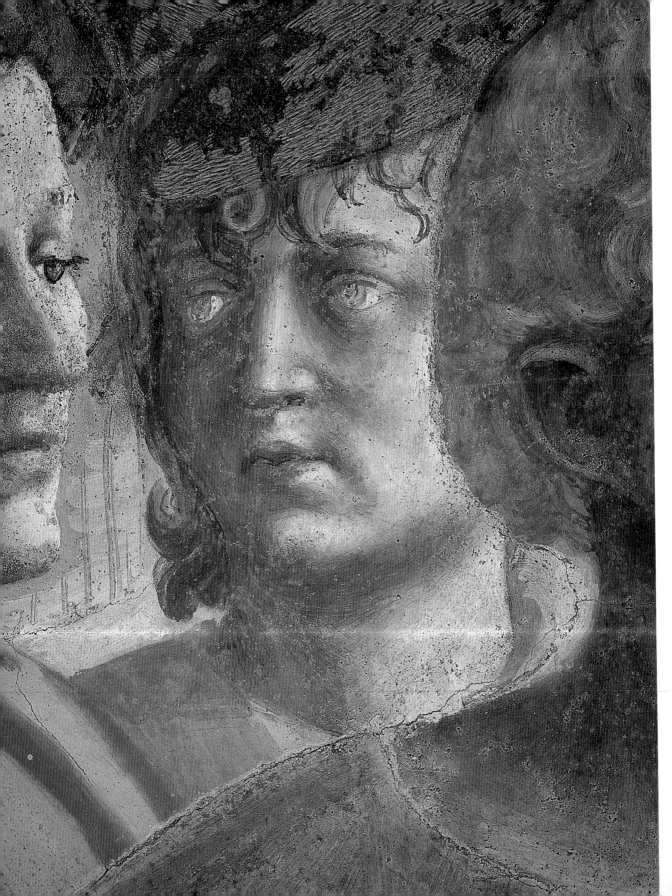

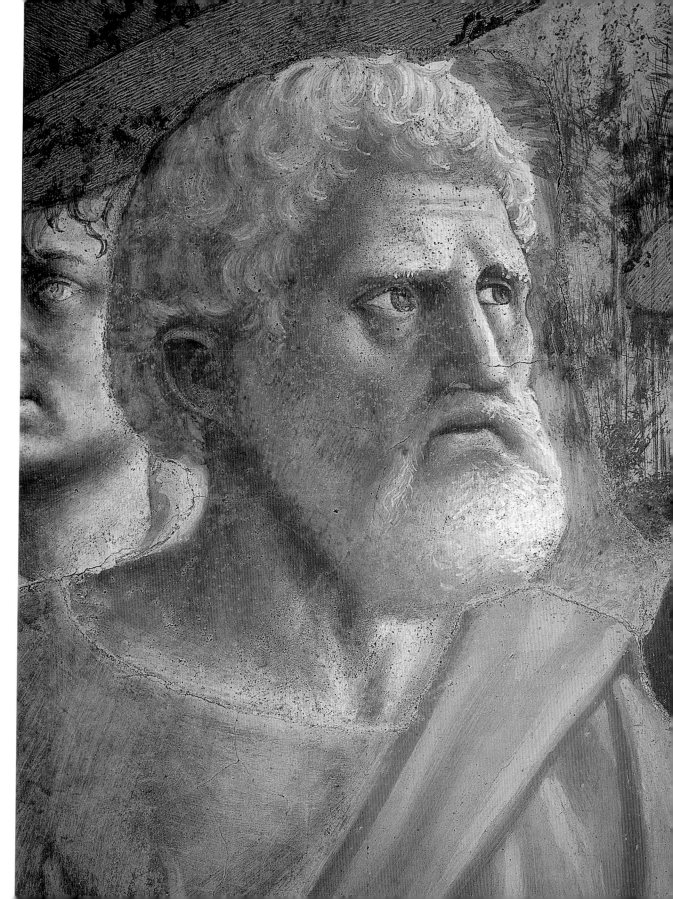

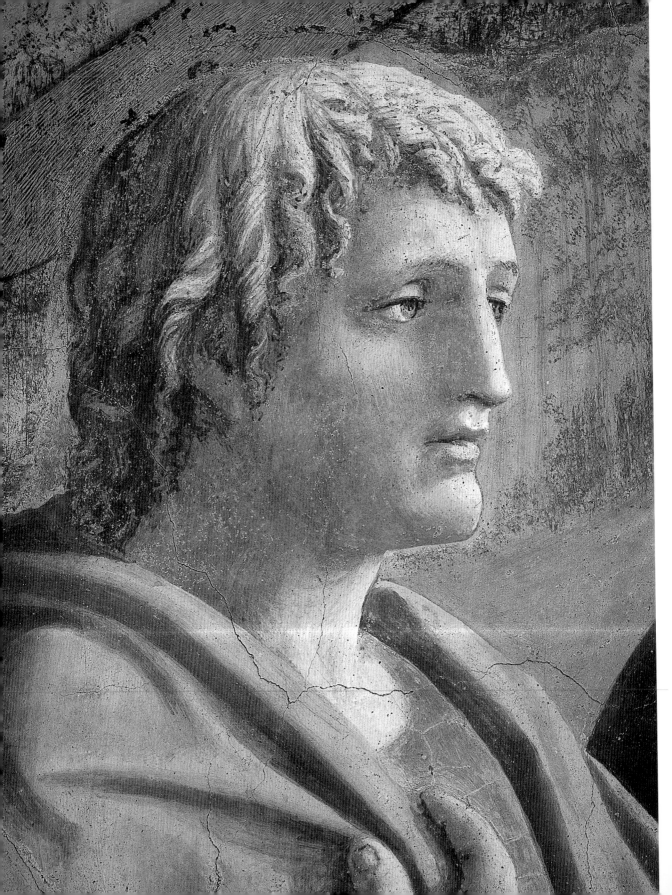

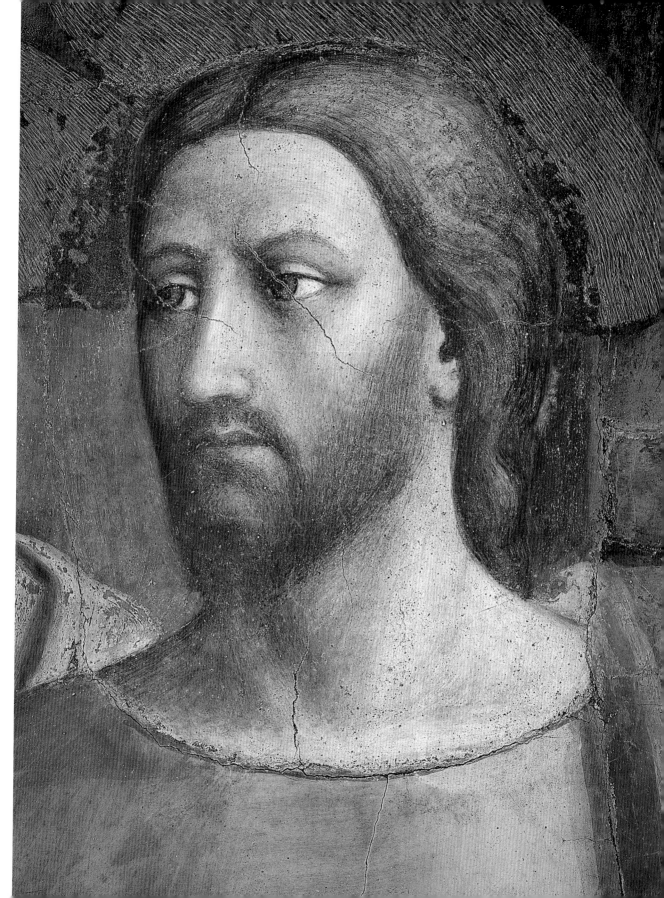

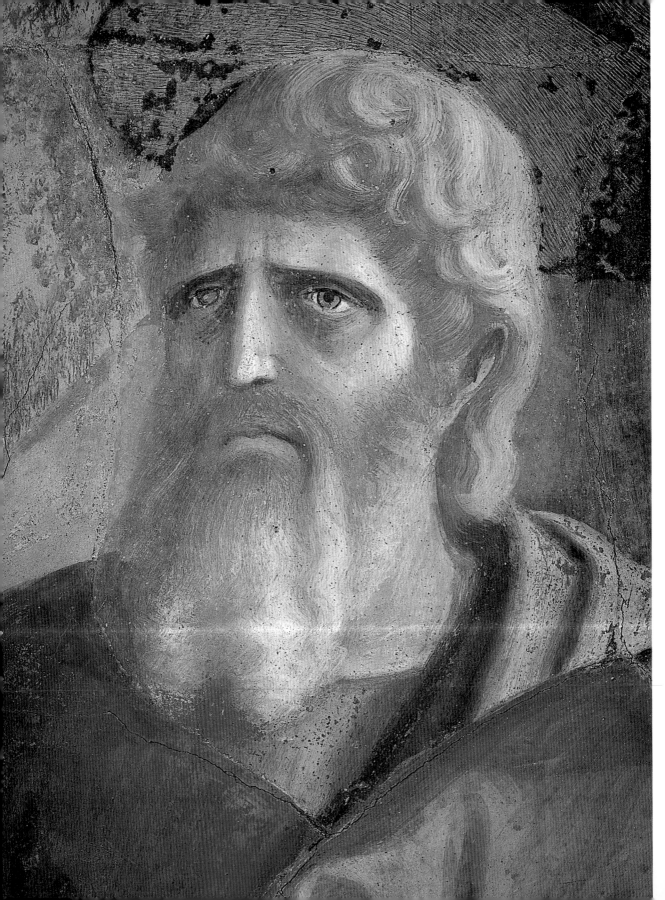

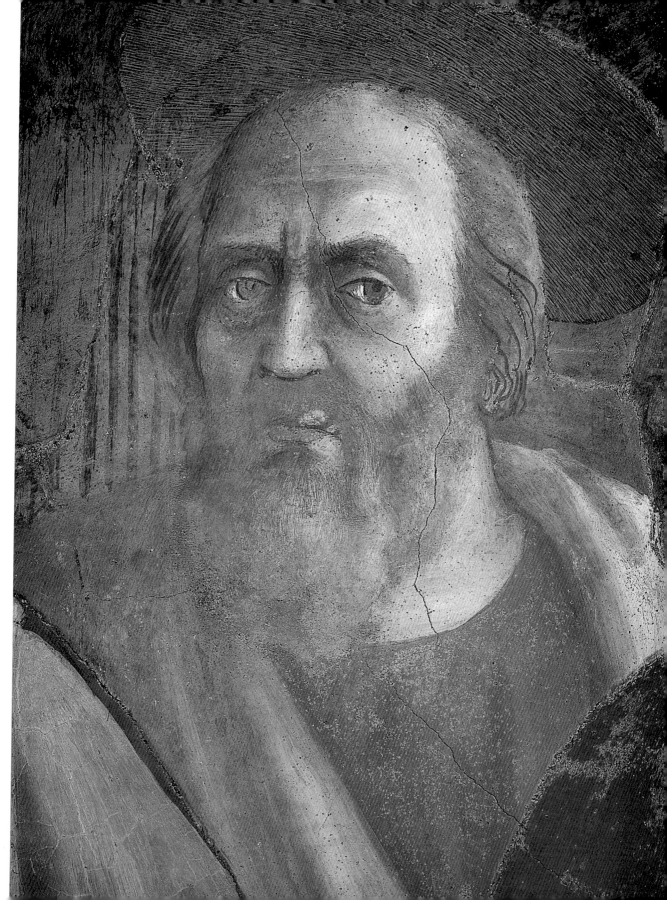

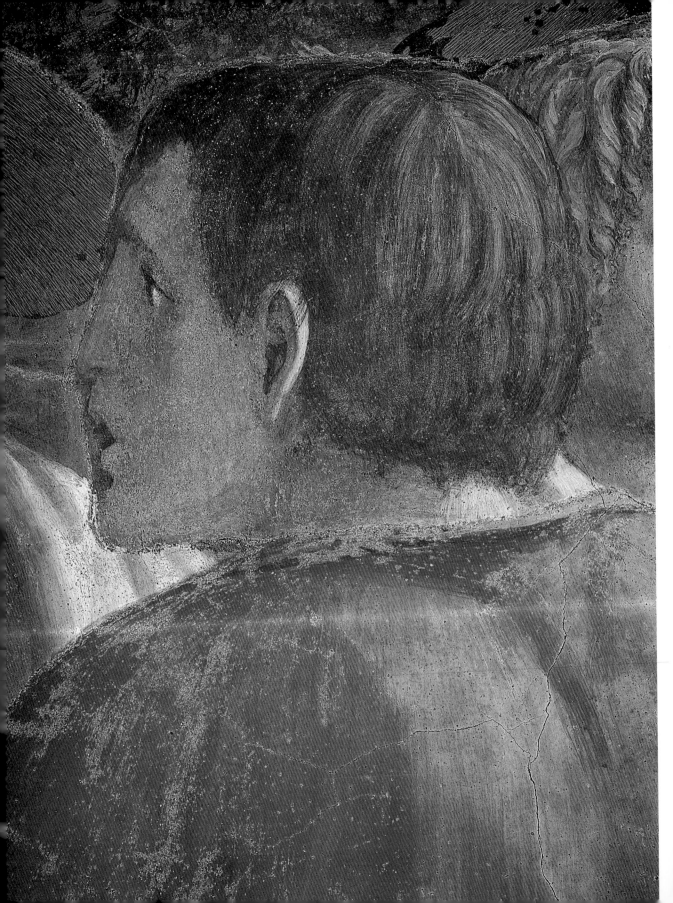

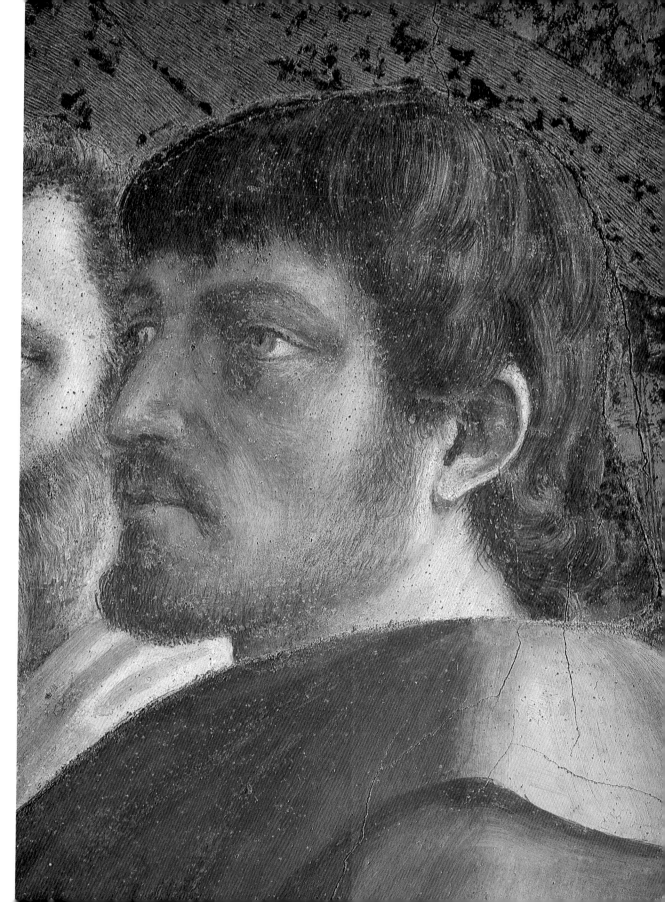

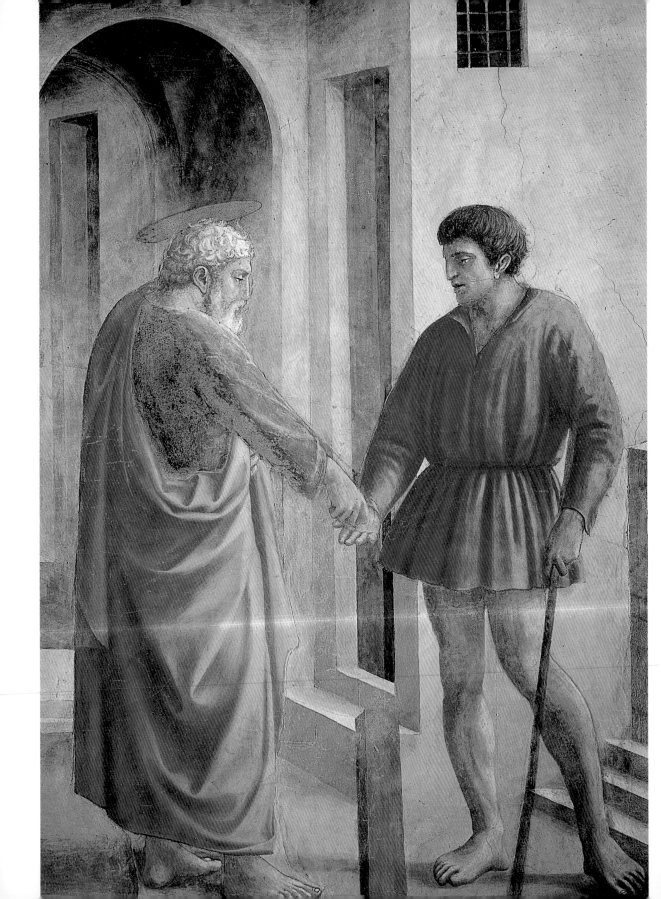

Saint Peter Heals with His Shadow
Santa Maria del Carmine, Florence
[cat. 3d]

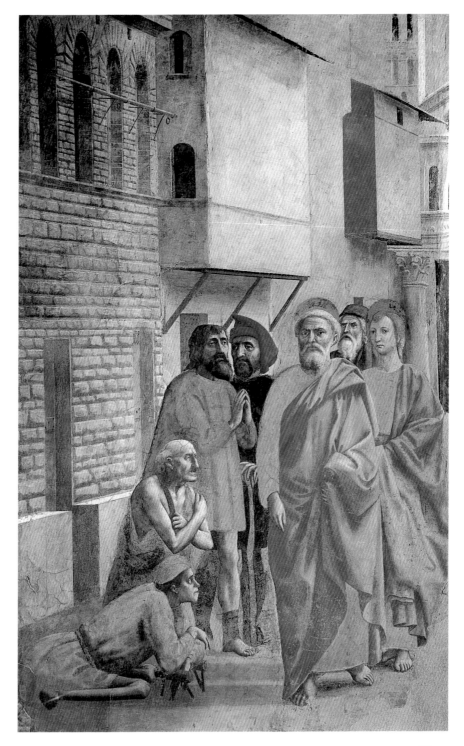

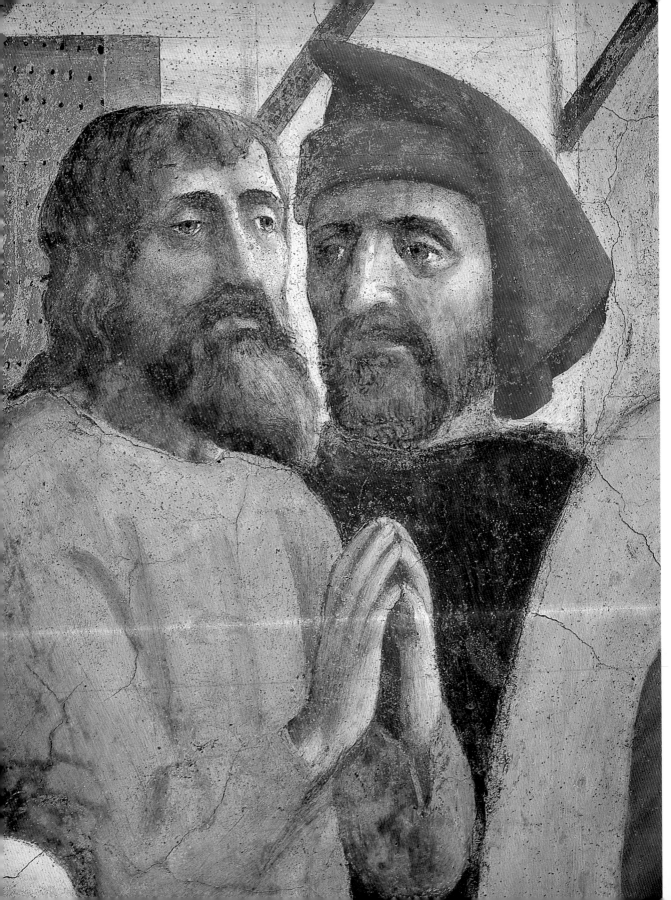

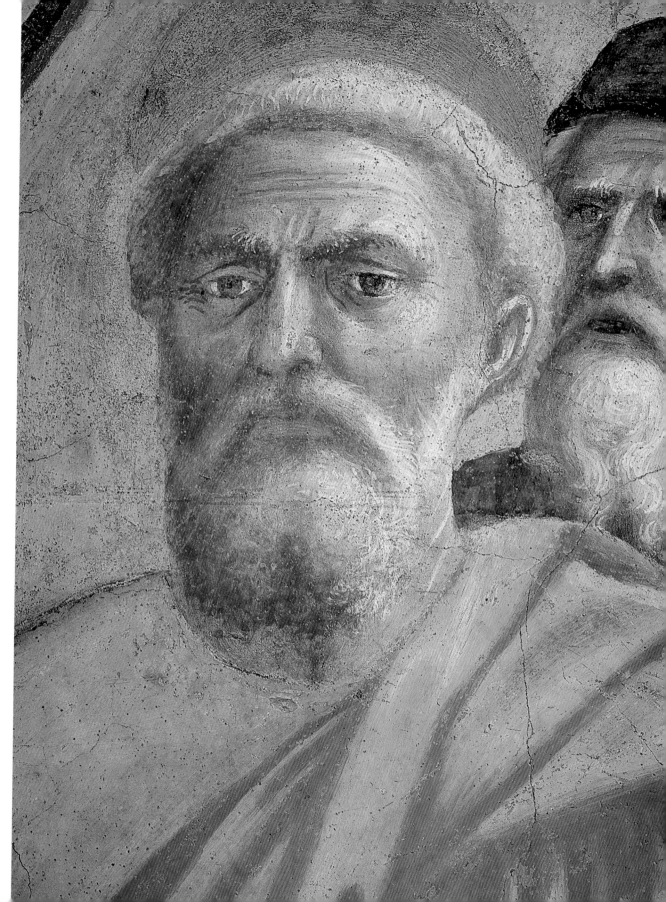

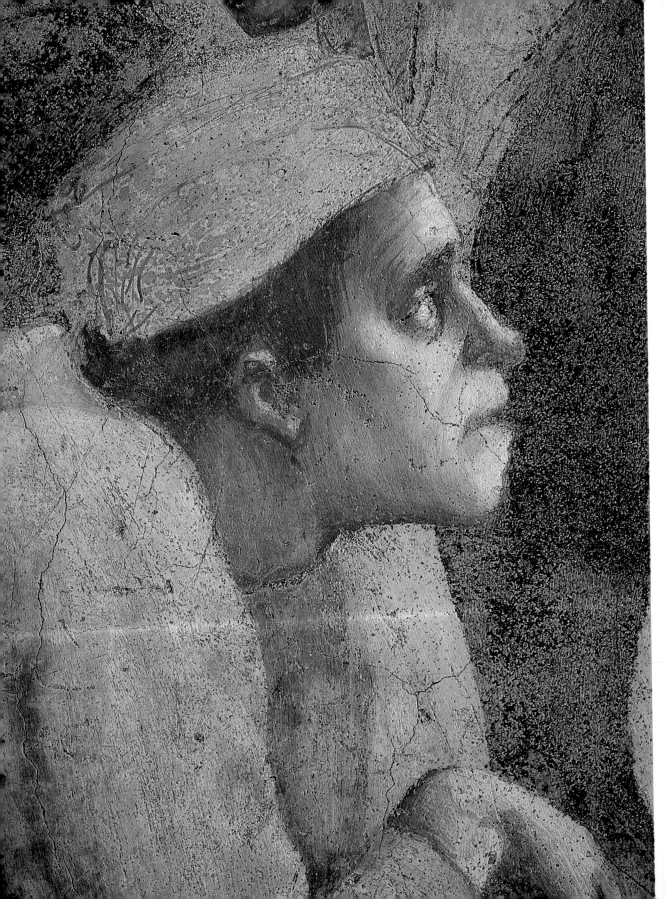

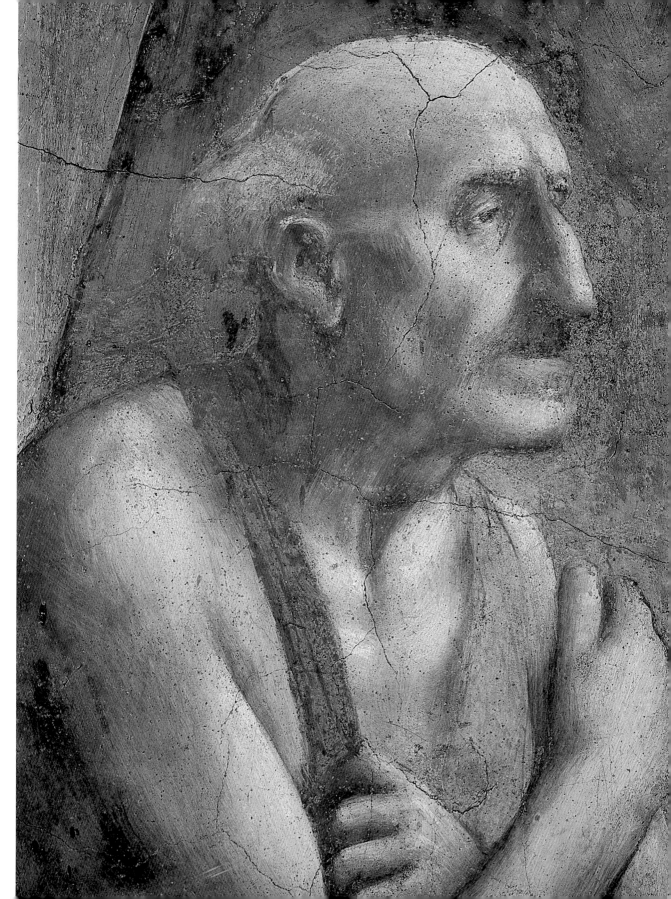

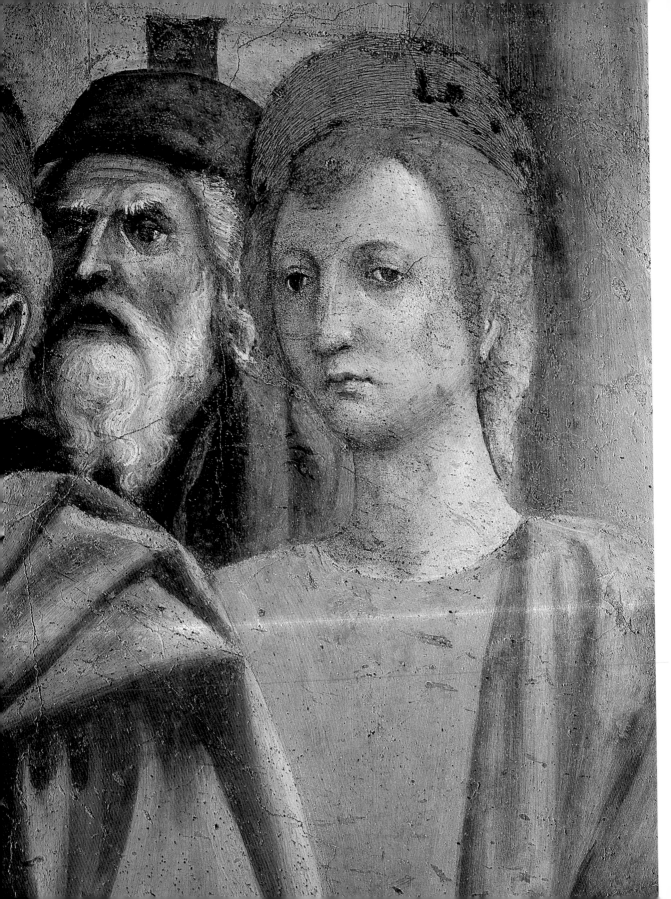

The Distribution of the Goods of the Community
and the Death of Ananias
Santa Maria del Carmine, Florence
[cat. 3e]

pages 60-63: [cat. 3e] *details*

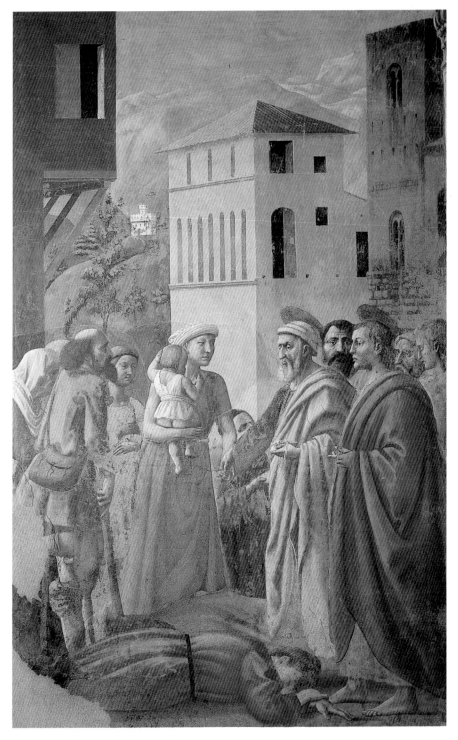

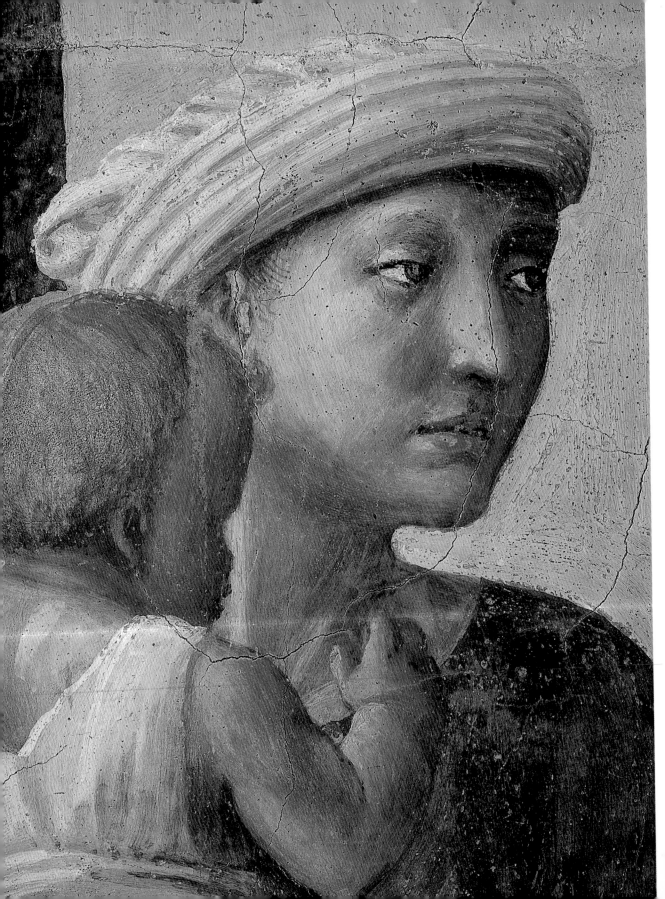

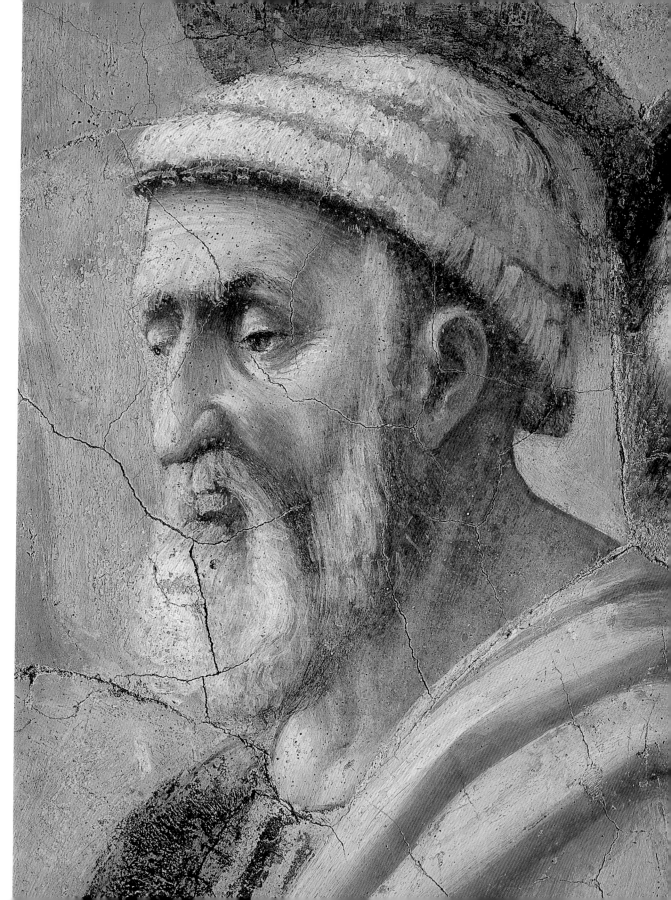

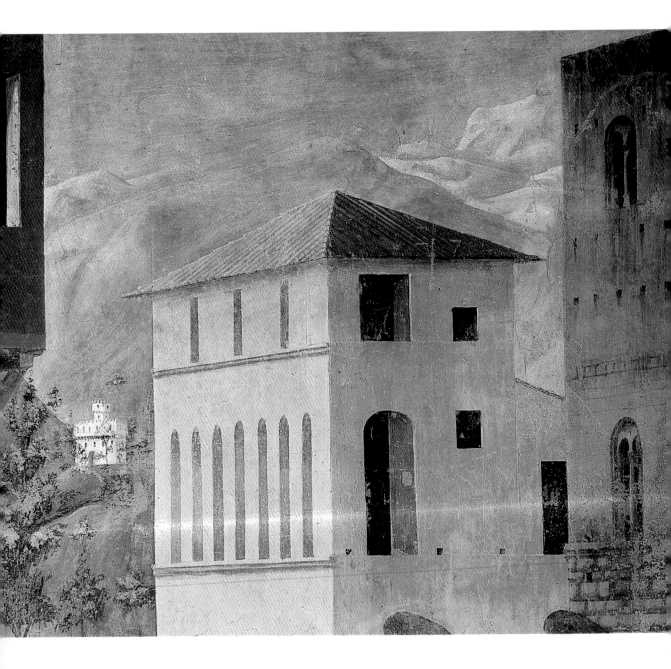

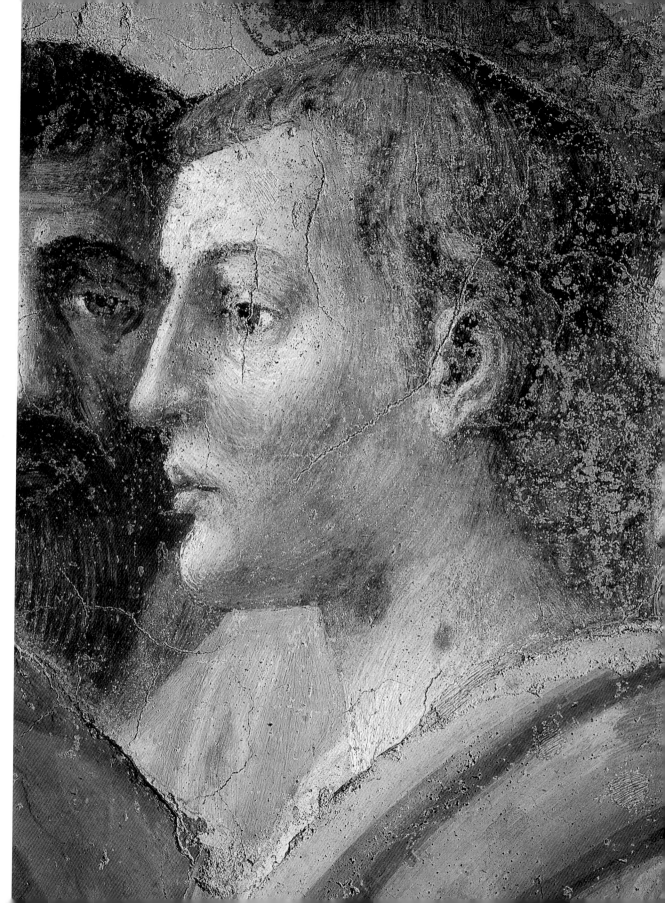

The Brancacci Chapel

The Resurrection of the Son of Theophilus
and Saint Peter in Cattedra
Santa Maria del Carmine, Florence
[cat. 3f]

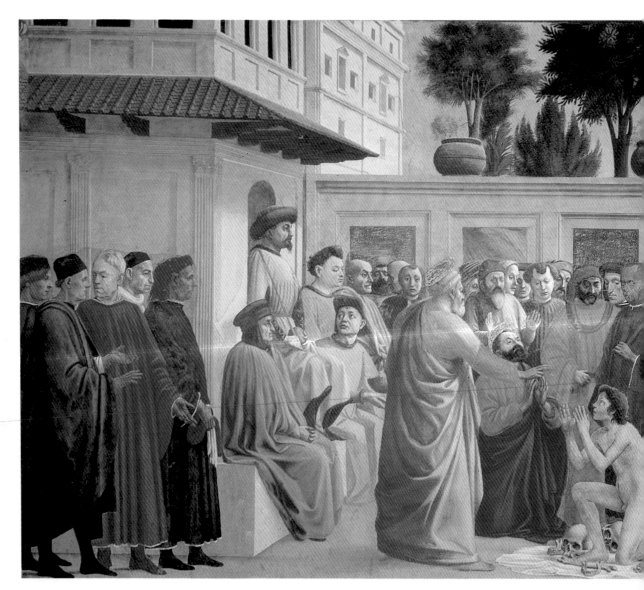

pages 66-70: [cat. 3f] *details*

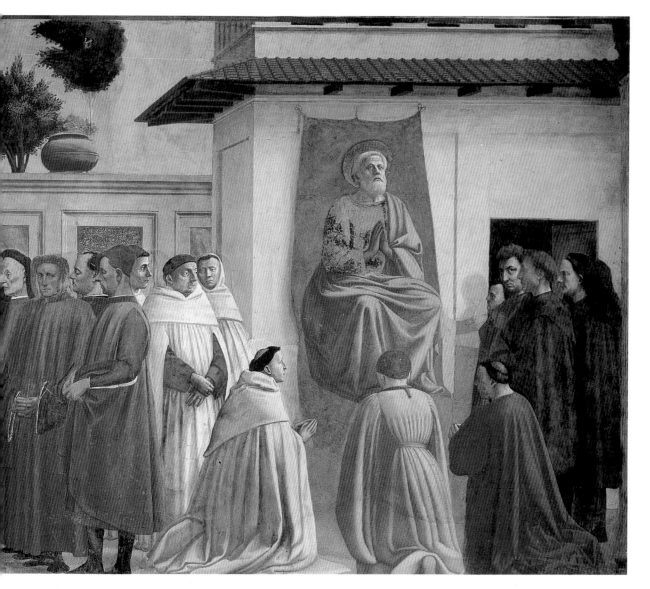

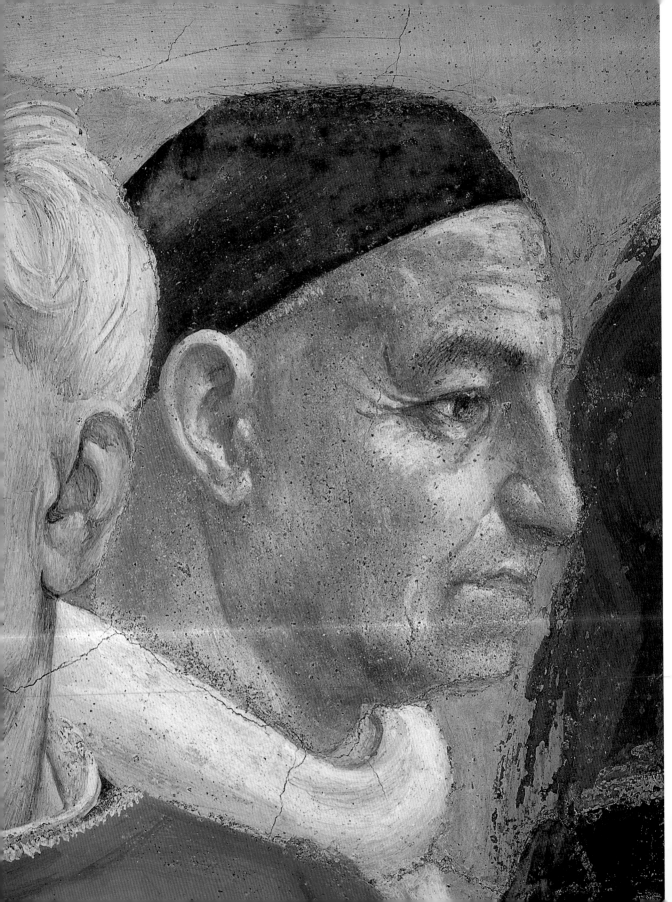

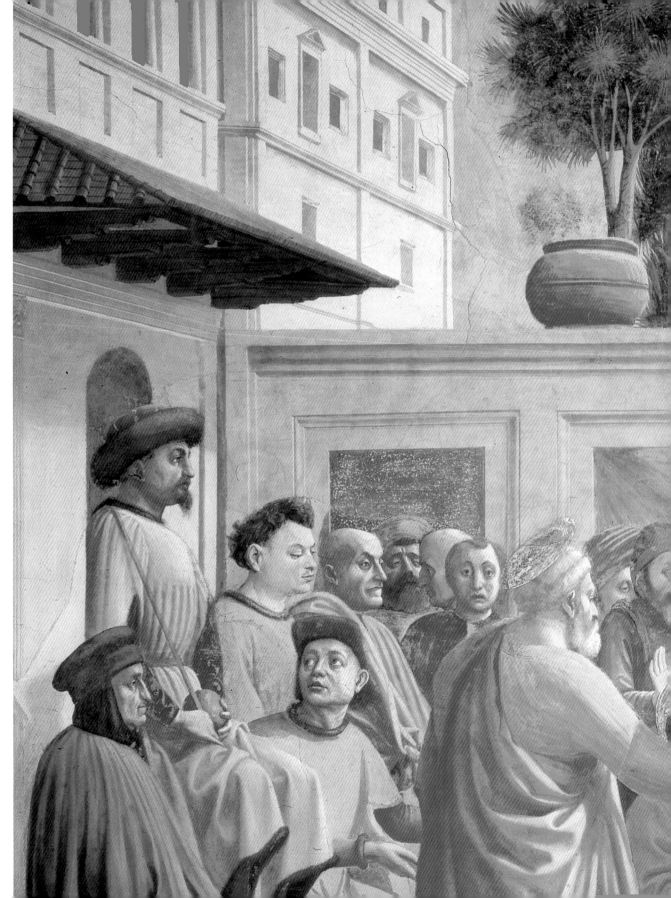

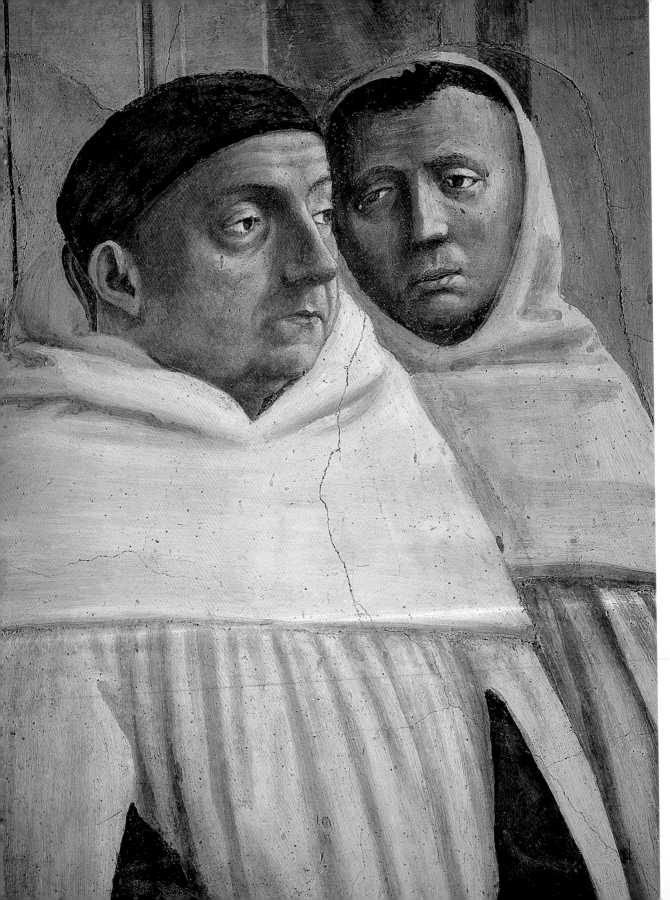

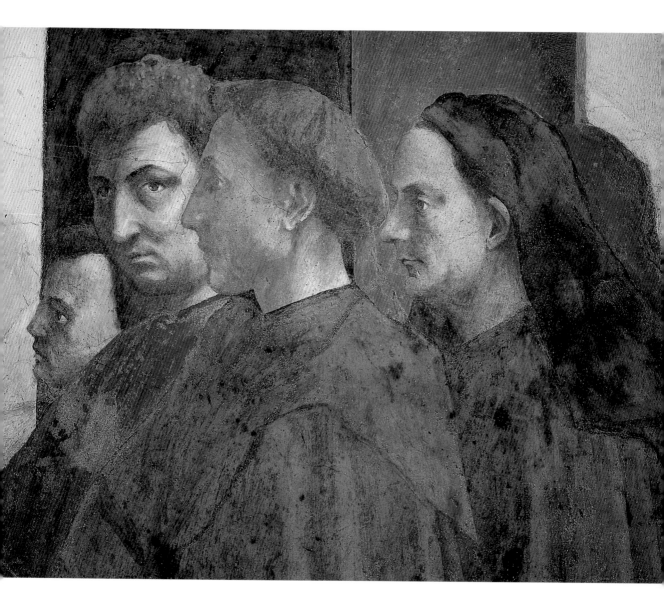

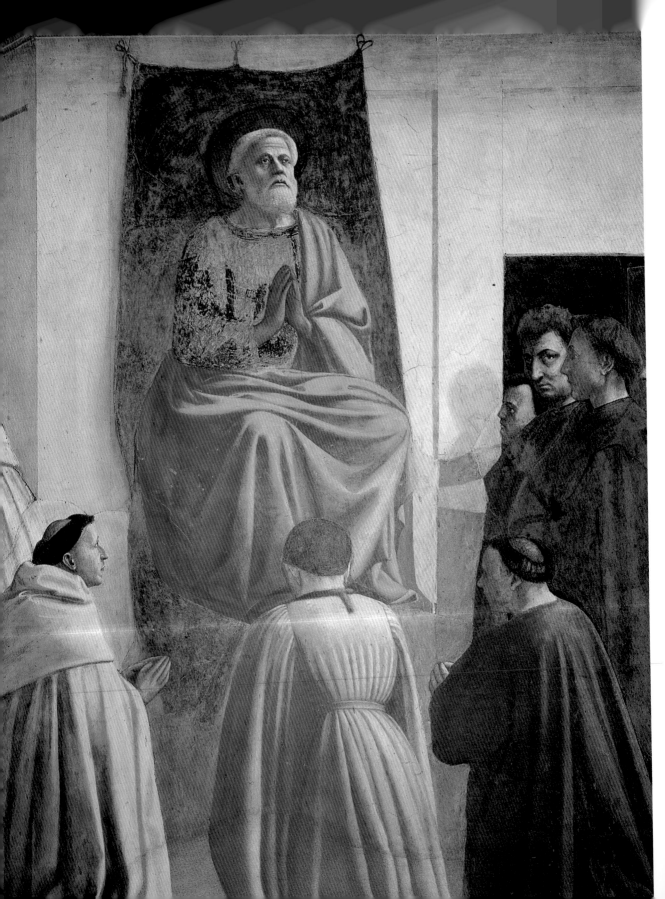

The Pisa Polyptych

Madonna and Child Enthroned
London, National Gallery
[cat. 4]

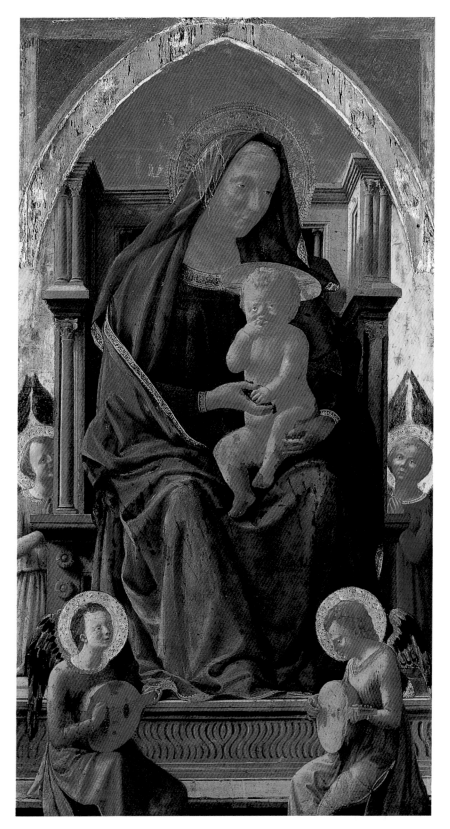

The Pisa Polyptych

Christ on the Cross with Saint John, Mary His Mother, and the Magdalene
Naples, Capodimonte Museum
[cat. 4]

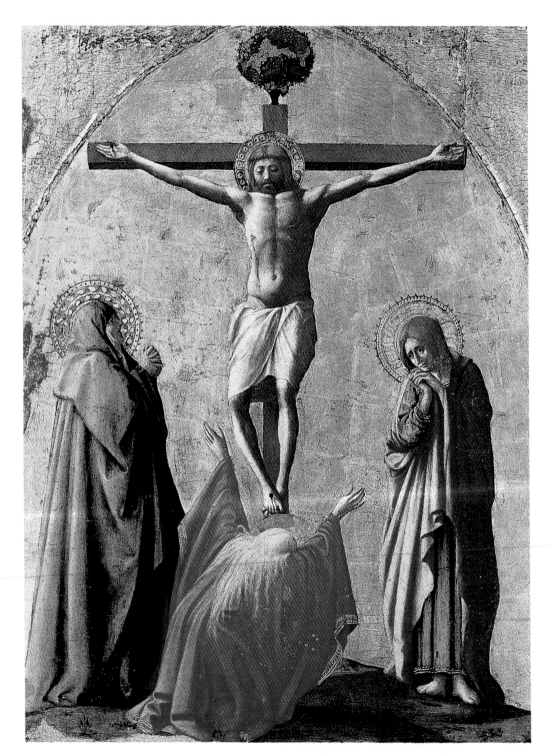

The Pisa Polyptych

Saint Paul
Pisa, Museo Nazionale
[cat. 4]

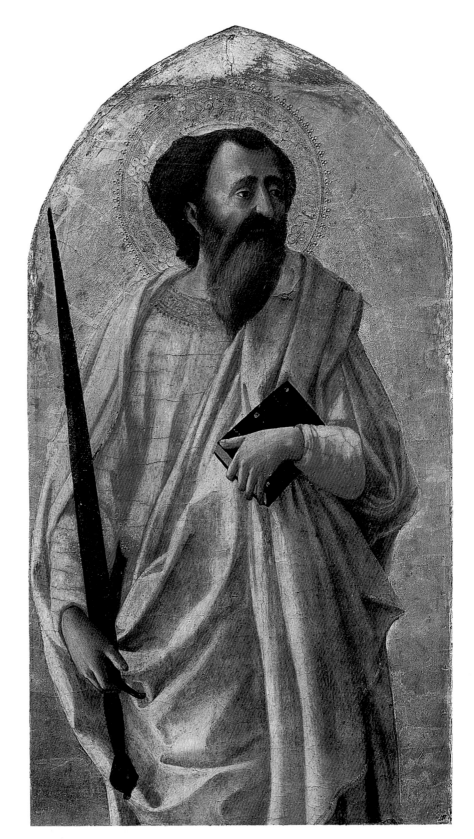

The Pisa Polyptych

Saint Andrew
Malibu, J. Paul Getty Museum
[cat. 4]

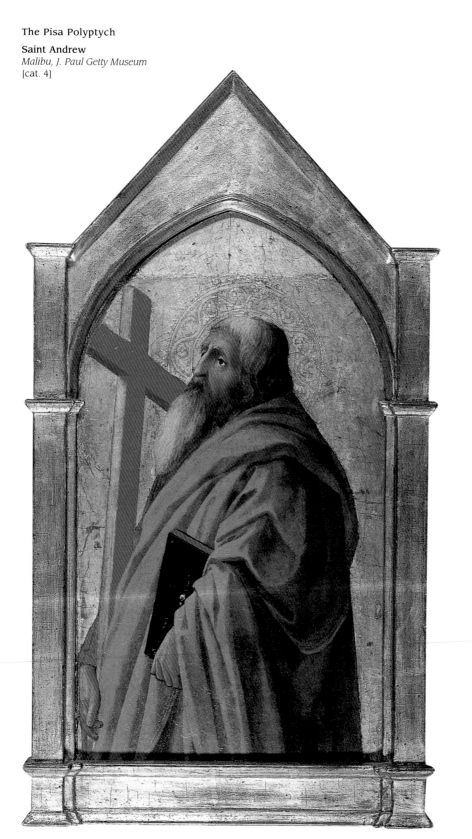

The Pisa Polyptych

Saint Augustine, Carmelite Saint
Berlin, Staatliche Museen
[cat. 4]

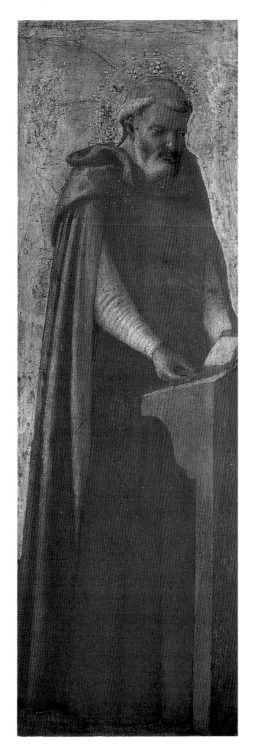

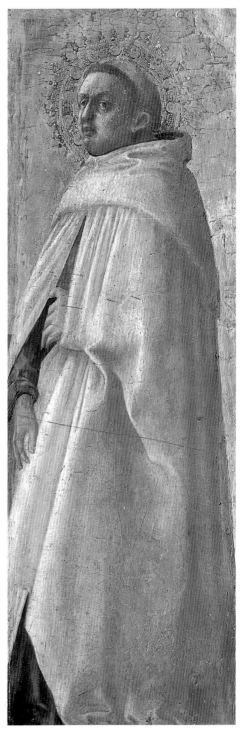

The Pisa Polyptych

Adoration of the Magi
Berlin, Staatliche Museen
[cat. 4]

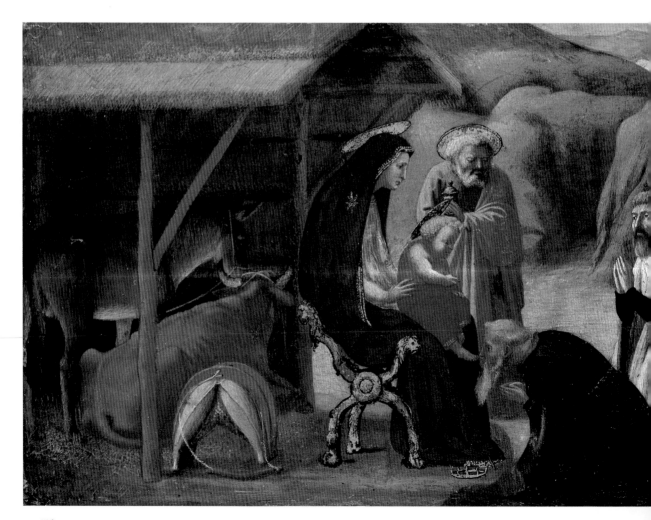

pages 78-79: *details*

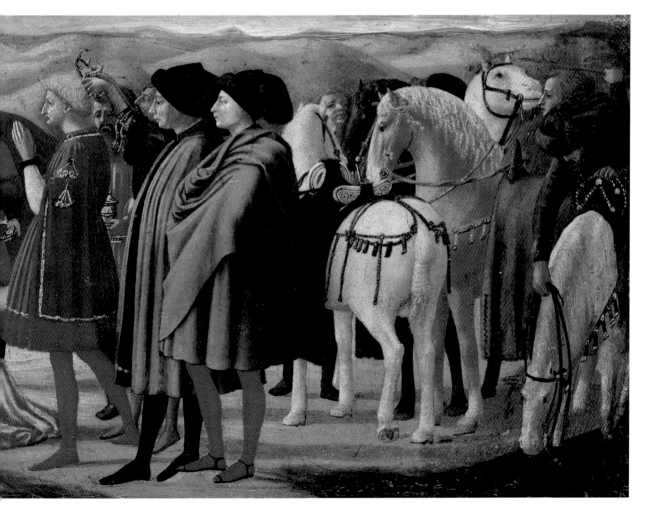

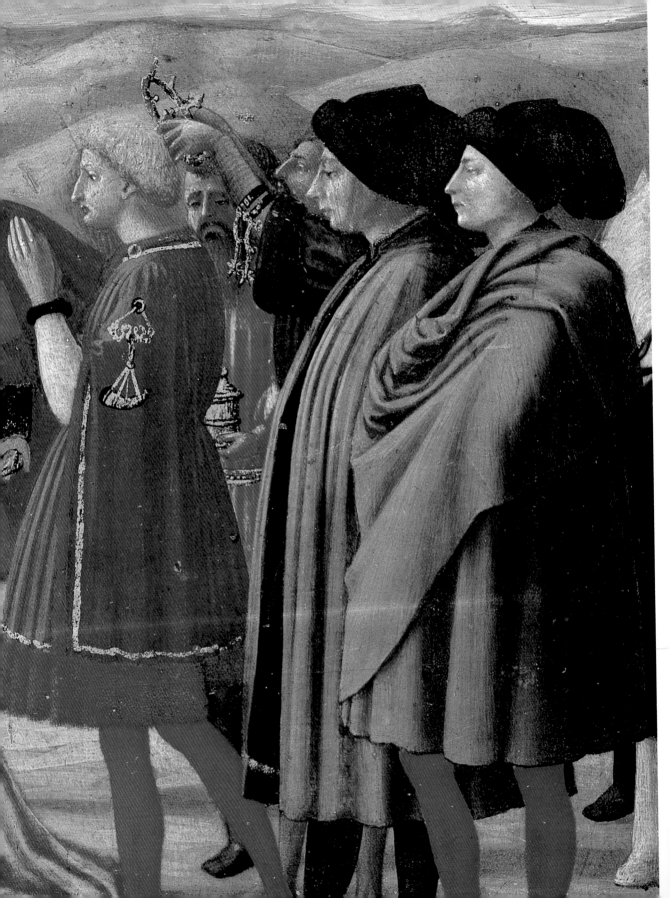

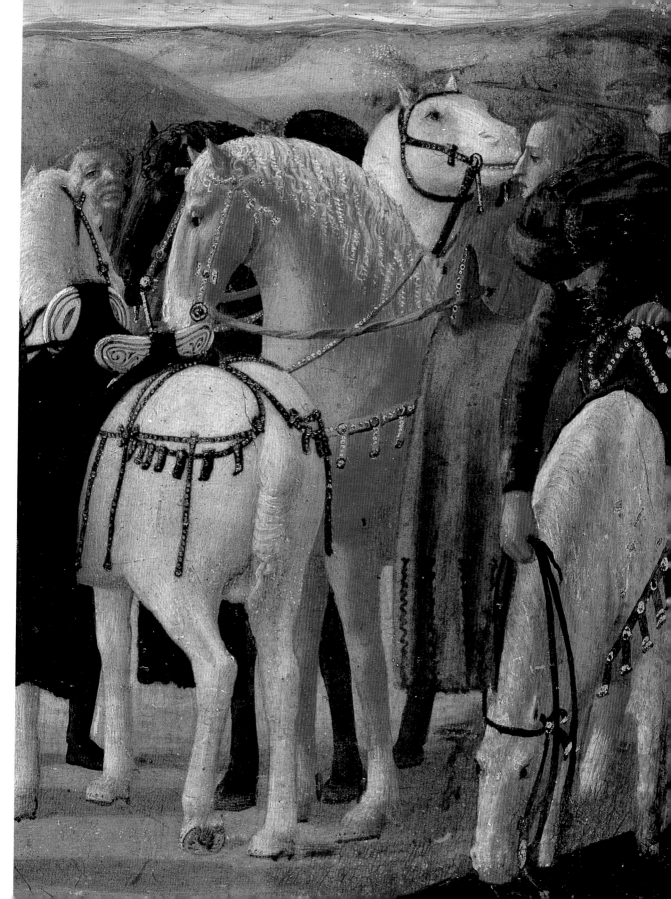

The Pisa Polyptych

The martyrdoms of Saints Peter and John the Baptist
Berlin, Staatliche Museen
[cat. 4]

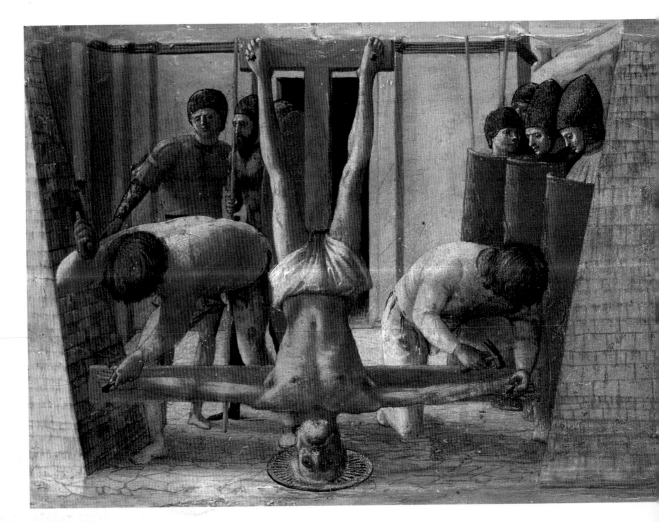

pages 82-85: *details*

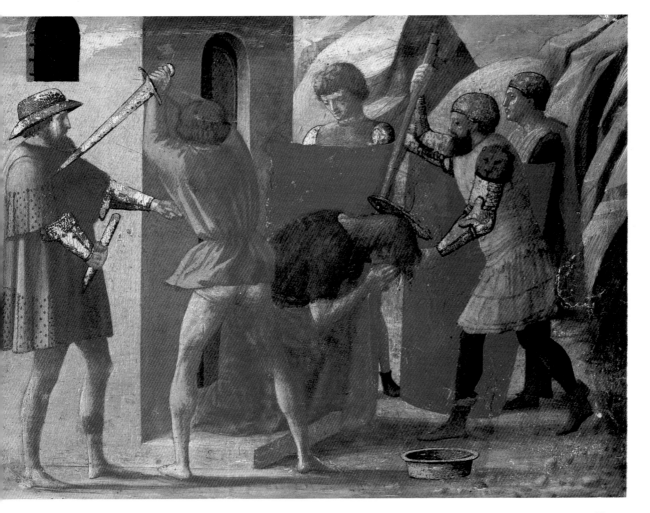

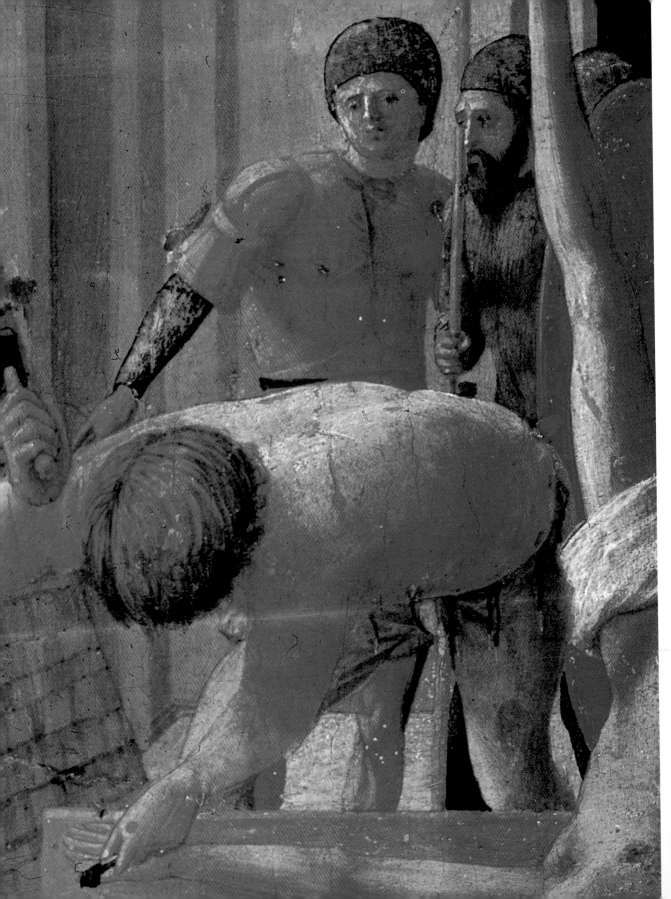

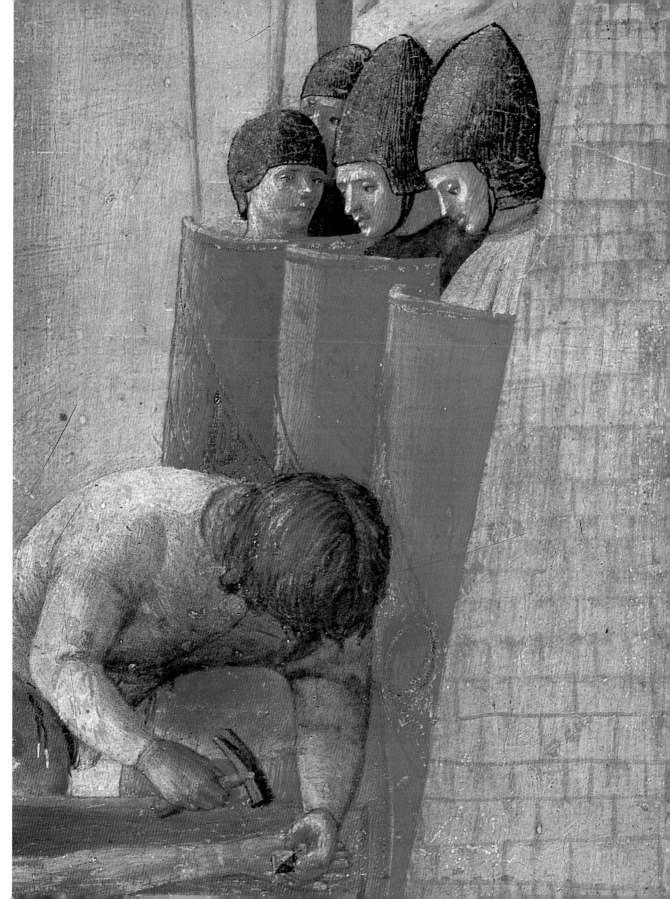

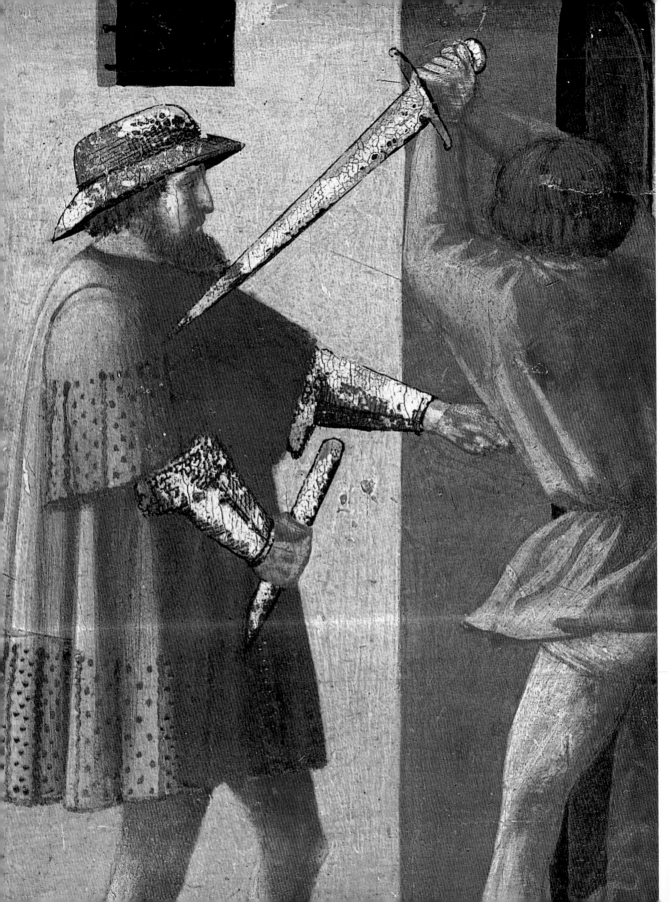

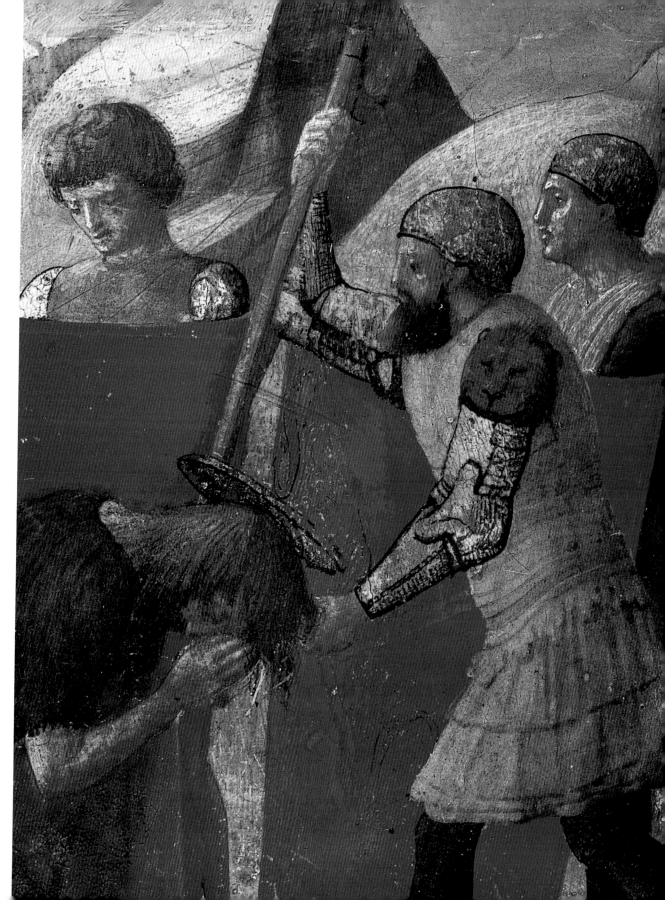

The Pisa Polyptych

**Saint Julian Murdering His Parents, and Saint Nicholas
Throwing the Golden Dowry to the Unwed Girls**
Berlin, Staatliche Museen
[cat. 4]

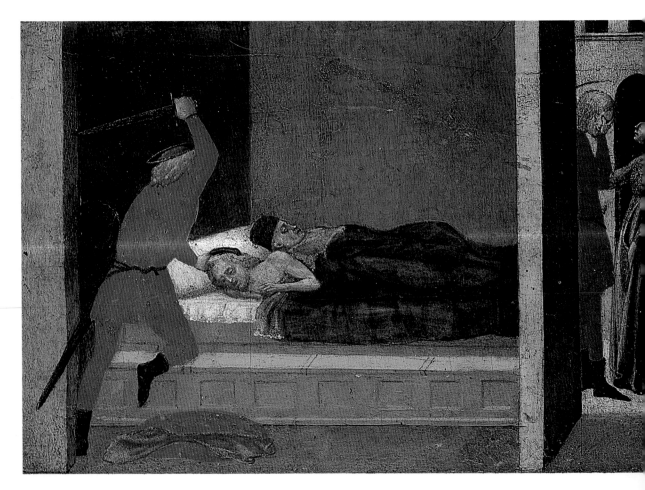

page 88: *detail*

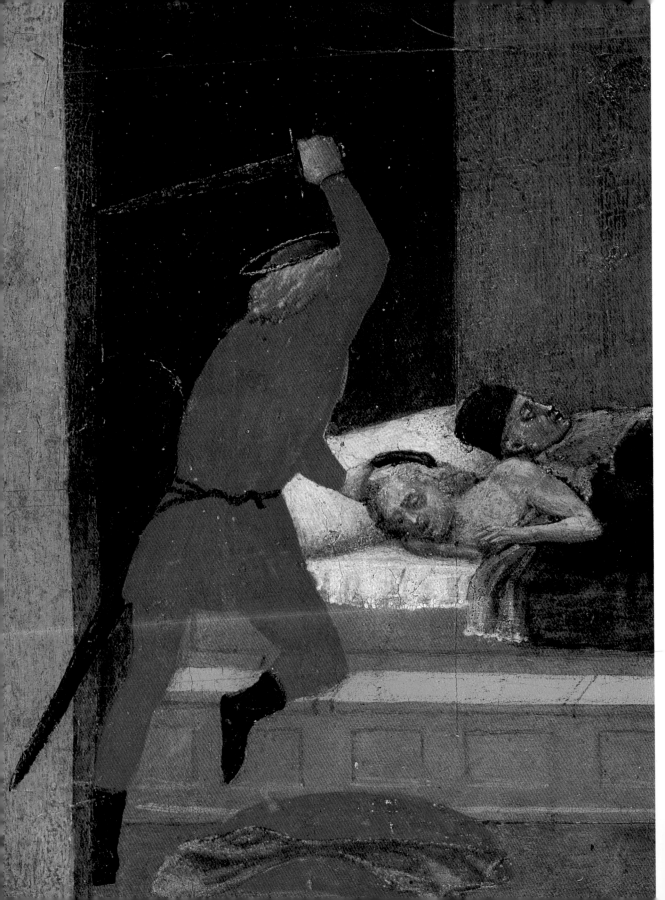

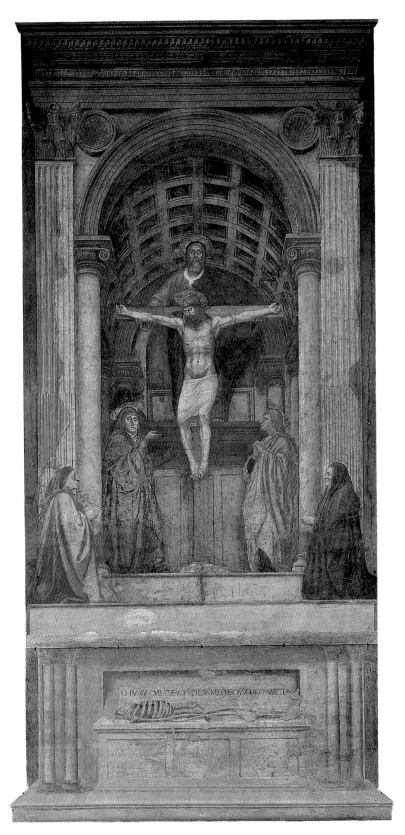

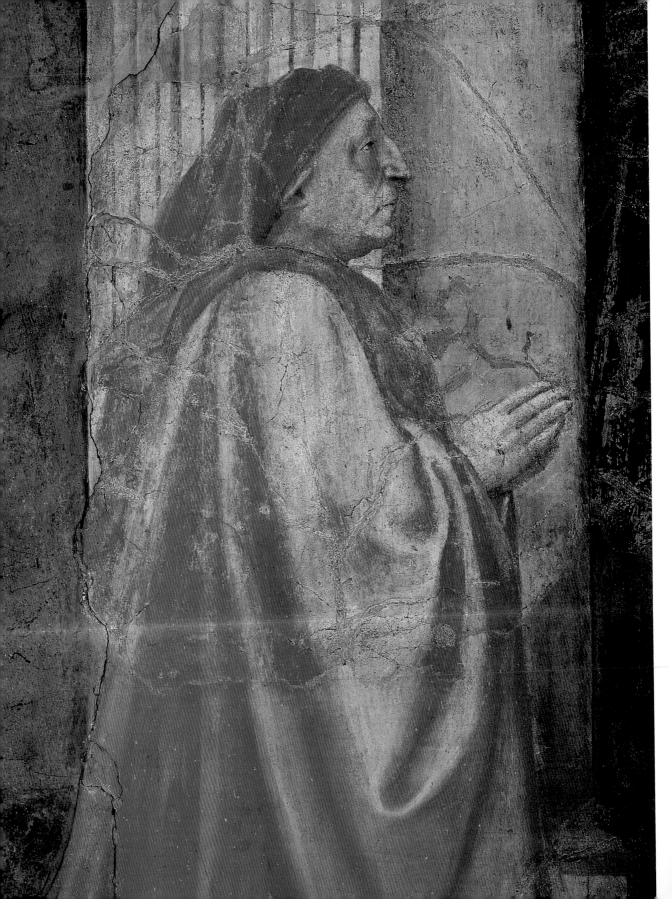

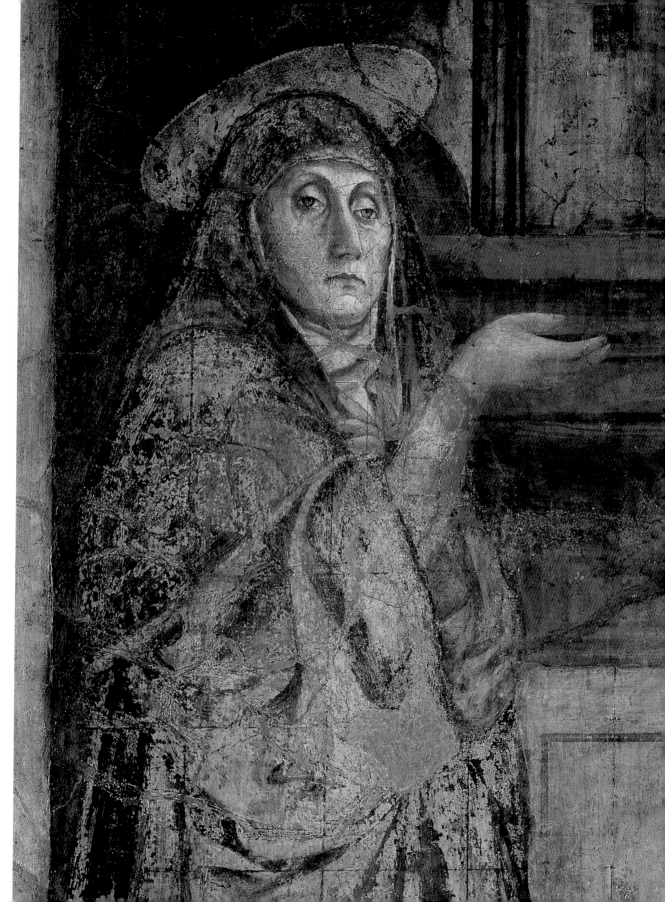

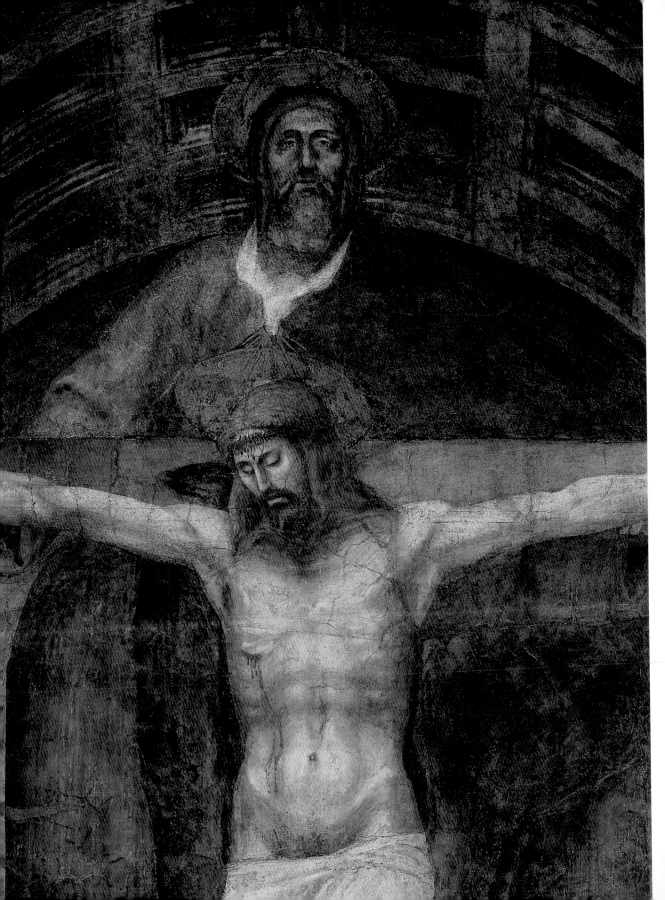

Saint Jerome and Saint John the Baptist
London, National Gallery
[cat. 6]

page 94: [cat. 6] *detail*

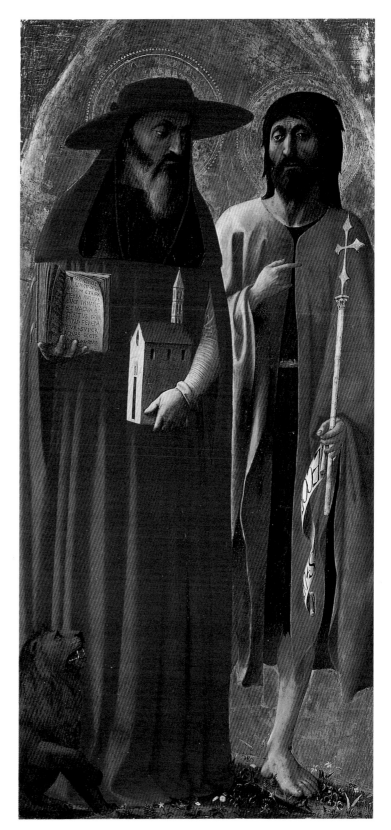

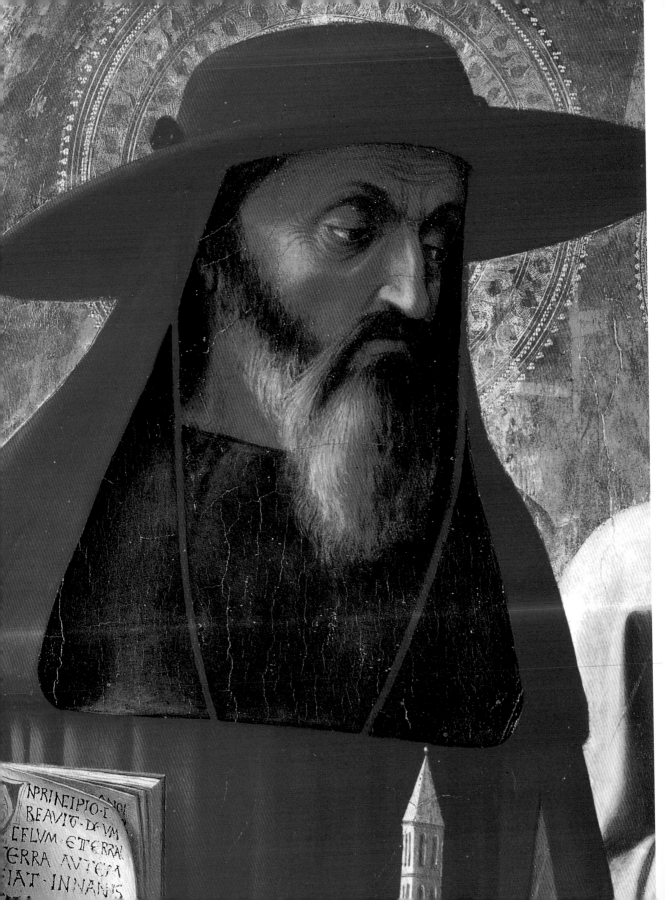

NPRINCIPIO·T
REAVIT·DFVM
EFLVM·ETTERRA
ERRA·AVTEM
IAT·INNANIS

Desco da parto
Berlin, Staatliche Museen
[cat. A1, *attributed work*]

pages 96-98: [cat. A1] *details*

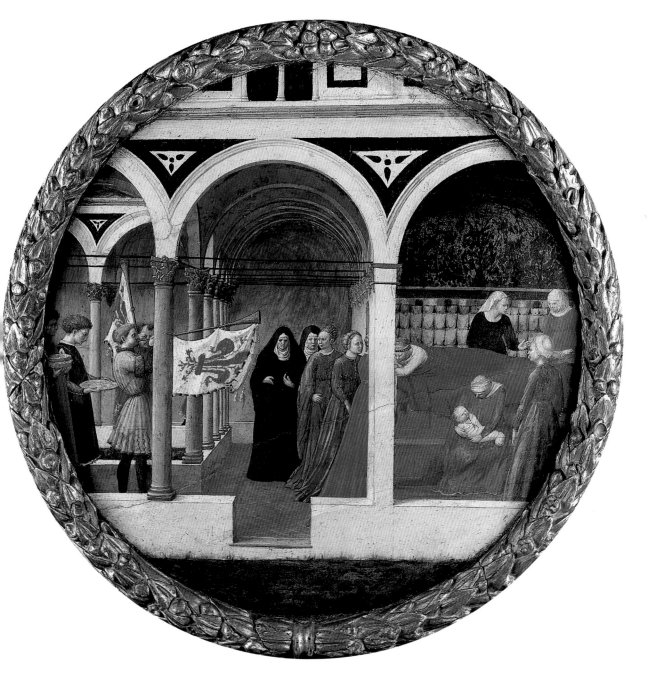

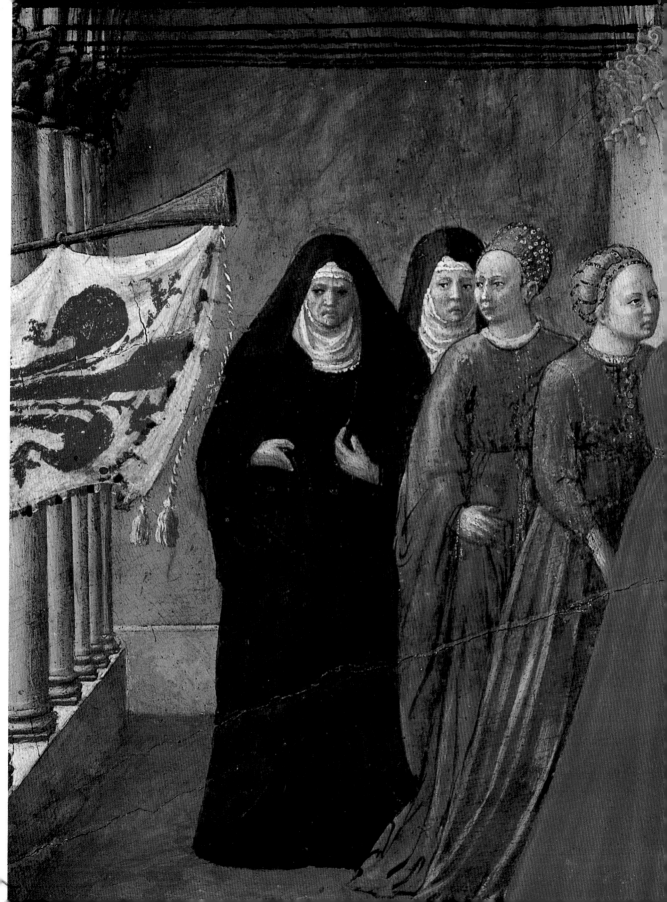

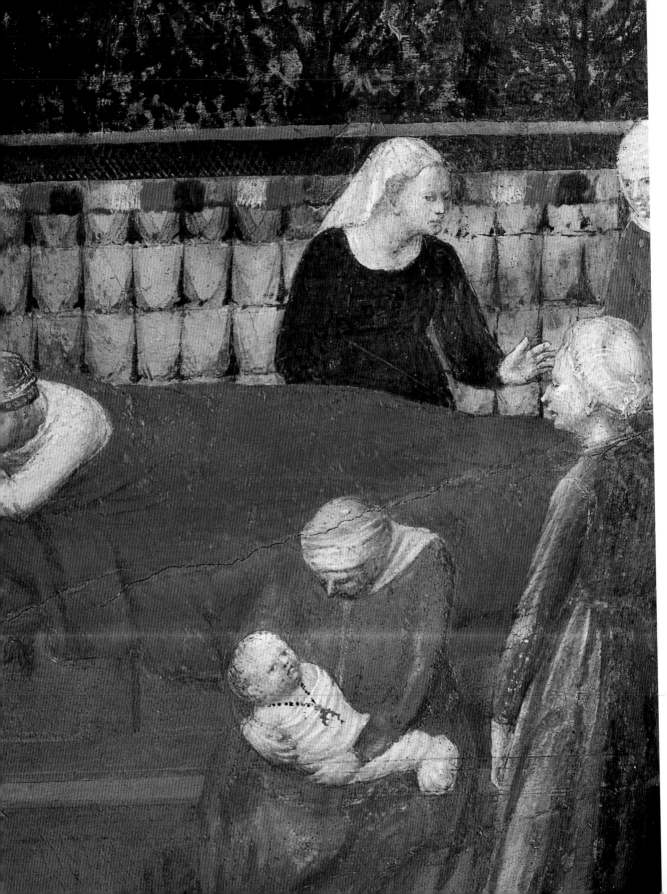

Madonna and Child (the so-called Casini Madonna)
Florence, Uffizi
[cat. A2, *attributed work*]

page 100: [cat. A2] *detail*

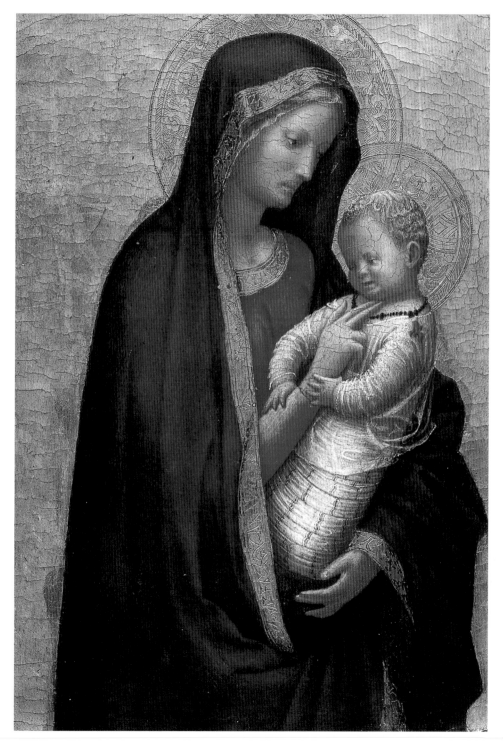

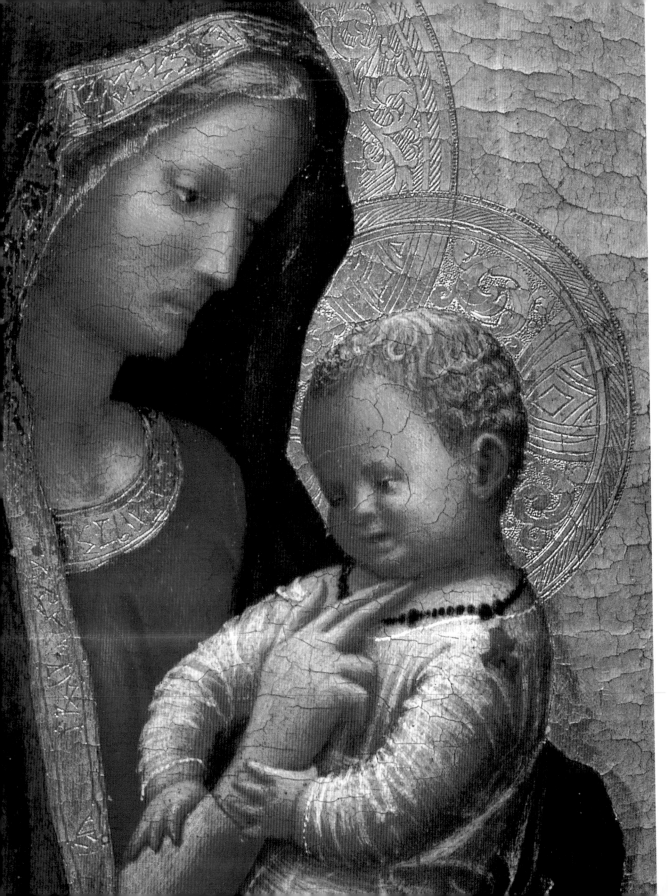

Male Portrait
Boston, Isabella Stewart Gardner Museum
[cat. A8, *attributed work*]

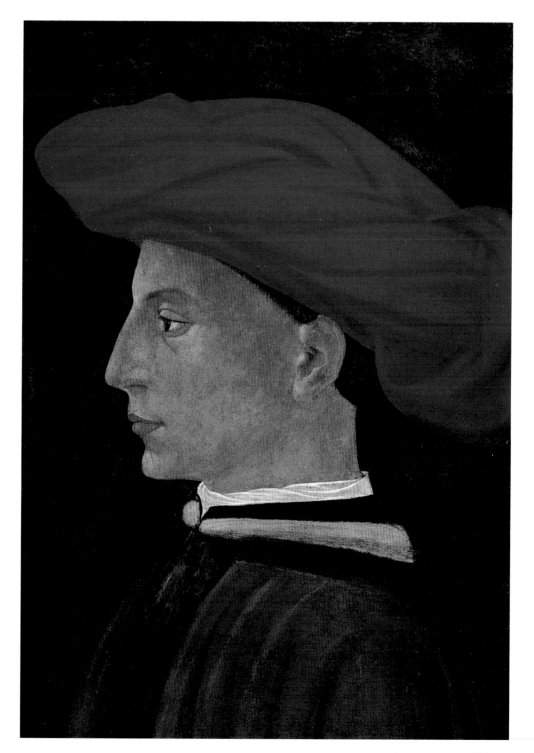

Male Portrait
Washington D.C., National Gallery
[cat. A9, *attributed work*]

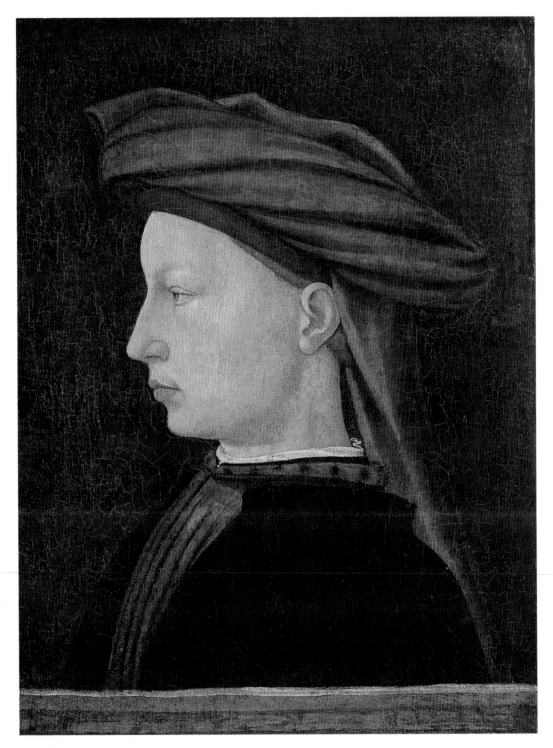

Complete Catalog of Works

The catalog numbers highlighted in gray
refer to the oeuvres reproduced in the color
plates section of this volume.

1

Madonna and Child Enthroned, with Two Angels and Saints Bartholomew, Blaise, Giovenale, and Anthony Abbot, 1422.

Tempera on cloth on wood.
Central panel: 108 x 65 cm.
Side panels: 88 x 44 cm.
Cascia di Reggello, Pieve di S. Pietro.

This remarkable painting was brought to the attention of the Florentine Sopraintendenza in the late 1950s by Don Renato Lombardi, who was then *parroco* of a small church—almost a chapel—near Cascia di Reggello, called San Giovenale. This hamlet is only about eleven kilometers—as the crow flies—from San Giovanni Valdarno, Masaccio's birthplace. Don Renato was convinced that the picture was important, and probably by Masaccio. At that time, the date on the painting was apparently covered by a later frame. Nevertheless, somehow—perhaps from documents, perhaps from prying the frame upward—the *parroco* knew the painting was from 1422, and also brought this early date to the attention of the Soprintendenza. Subsequently, it was carefully studied, and extensively published by Berti.

The painting's appearance is remarkable because it represents a great discovery relating to the very basis of Italian Renaissance painting. It also shows us the young Masaccio's hand, and this has nothing to do with Masolino. Until the painting's discovery, many critics had believed Masolino's influence on Masaccio's training had been important—the elder painter was born about 1380, and came from Panicale, now a farm near S. Giovanni. Since they worked together, and Masolino was a whole generation older, it was presumed likely that there had been an association of master and pupil. The painting shows us that there is no Masolino influence at all.

The painting was recorded on various occasions after a "bella" *Madonna and Child* was mentioned in the church in 1441. It's unlikely that somewhere so small and isolated would have had more than one altarpiece, so Masaccio's painting is more or less certainly the one mentioned. It has been suggested that the picture was painted in Florence, but remained in the city until sometime in the 1430s, when it was brought to San Giovenale. Perhaps this happened when some of the Castellanis—probably the family that commissioned the picture—were exiled after 1434 by Cosimo Medici. Or perhaps it was brought to San Giovenale by Leonardo Bruni, Florence's chancellor for thirty years, when he came into much of the Castellani property sometime after 1434.

When first published, there were a few scholars who refused to accept the attribution to Masaccio (Longhi, Procacci, Bologna). But the date clearly inscribed in Roman characters, the use of one-point linear perspective, the nude infant eating grapes, and the physiognomy of the Madonna and her child all seem to indicate unquestionably that this is a work by Masaccio, age more or less twenty. Moreover, the work seems now, at a distance of almost forty years since its first publication in 1961, exactly what we would expect from the young Masaccio's hand.

First of all, in this painting Masaccio has already understood the principles of one-point linear perspective: the lines still so clearly marked on the floor, under the saints and under the Madonna's throne, if extended, would come together at a point just below the Virgin's chin. This is, of course, reminiscent of paintings from the mid-Trecento by Ambrogio Lorenzetti, particularly the *Presentation at the Temple*, now in the Uffizi. But Masaccio has gone further than Lorenzetti and has fit his picture into a logical system where a more convincing illusion of space is created by the orthogonals seeming to come together at a single point in the picture—or, if one prefers, in the imagined space. Masaccio has also grasped much of what he would need to know to go forward with the development of chiaroscuro. In particular, the Madonna's face, and the infant Christ, are strongly modeled in space—perhaps more strongly than any post-Roman picture that had appeared in Europe up to this date. Masaccio's realistic modeling has included giving form to the implied feet of both inward-turned angels under their red robes. It also makes the two facing sides of those robes a darker red, and uses a much stronger apparent light on the left-hand angel, as though from a light source to the left. Still, there are as yet no cast shadows—a technique also used by the Lorenzetti in their frescoes in the Palazzo Pubblico in Siena, but used in a nonsystematic and fairly minor way. Masaccio eventually unifies his pictures by having light fall uniformly, as though naturally, from a single source, and so cast shadows appear simply and logically in his Pisa triptych, as well as in the Brancacci Chapel. Similarities between elements in Masaccio's San Giovenale painting and some also in the works of Donatello, Brunelleschi, Giovanni Toscani, Beato Angelico, and Giovanni del Biondo have also been pointed out, with the obvious suggestion that these men could have influenced the young Masaccio.

This picture is also similar in many ways to a painting that has disappeared (Cat. A13) after its apparent export from Italy sometime in the 1950s or '60s but that, at some point, was certainly overcleaned: much of the shading is gone from the face, particularly around the eyes, while the cast shadows and strong modeling on the baby are all but gone. This unknown painting may well be an intermediate step in Masaccio's development between the San Giovenale triptych and the Pisa *Madonna*.

The San Giovenale triptych is of the *Madonna and Child Enthroned* in the central panel and two saints in each of the side panels—Saints Bartholomew and Blaise on the left, and Saints Giovenale and Anthony Abbot on the right, each with his individual symbol. At the Virgin's feet are two angels turned inward toward her, the one on the left gesturing with open

arms, the one on the right praying. The throne appears to be of wood, befitting Masaccio's family background as cabinetmakers, but was perhaps meant to seem like marble. It has inlay decoration on the uprights that face outward. Mary is clothed in a large, full garment that leaves only her hands, face, and neck bare. Originally, this garment must have been a rich, deep blue. Today, it is nearly black. The Christ child stands nude supported by the Virgin's right hand, except for a beautifully painted thin veil over the lower part of his torso and legs, which he holds up with his right hand. Certainly, this is not the first time a nude Christ child appears in Florentine painting—there are earlier examples by the Masters of San Martino a Mensola and of the Strauss Madonna, as well as by Cenno Cenni. The child is holding grapes in his left hand, while eating them with his right one—an image Masaccio also uses in the Pisa painting of 1426, a reference to the Eucharist. Grapes also appear in the lost *Madonna and Child* (Cat. A13). Originally, there was a clear inscription in gold on the front step of Mary's throne, which seems to have read *Ave Maria Dominus Tecum Benedicta*. Another inscription, in Arabic, is incised into the Madonna's golden halo. Apparently, this refers to Allah and to his prophet Muhammad. Why such an inscription should embellish the mother of Christ is difficult to establish: perhaps the new Jerusalem that some Florentines hoped their city was to become at that moment included a rapprochement with the Arabs? Perhaps Masaccio's theology was more liberal, advanced, and more Christian than even his *Trinity-Resurrection* would indicate? Perhaps there is some specific reason that has been lost. In any case, Gentile da Fabriano used similar characters, as did Giovanni Toscani, and as did Masaccio himself in other paintings. Whatever the origin and purpose of these Cufic inscriptions, they were certainly intentional. Why, we don't know. A third inscription runs along the lower base of the whole triptych, naming

the four saints above and giving a date—23 April 1422. This last inscription is in Roman letters, instead of the Gothic ones normally employed in paintings up to this time. It has been suggested that each of the four saints refers to a member of the Castellani family and that these may be portraits. The Castellani family held much of the land in the San Giovenale area in the 1420s, and that one of these, perhaps Vanni Castellani, or his son Bartolomeo, was the commissioner of the picture. The two saints on the left are much flatter than those on the right and stand less solidly on their feet. Those on the right are more sculptural and more balanced.

These last, in turn, are less convincingly modeled than the mother and child. Either the picture was painted in three distinct moments, or Masaccio advanced with giant steps in his development. Both are possible, or neither.

The date in the inscription doesn't necessarily mean that the picture was finished at that moment: it may be a date well before the artist's termination of the painting, from some earlier moment, such as a dedication in the church, or some event in the commissioner's life or family. And Masaccio was certainly a prodigy of enormous genius, whose effect on painting has probably never been equaled. So he may indeed have progressed with great rapidity. Or perhaps he began the painting considerably before the date on it, but only finished it at more or less that date.

2

Madonna and Child Enthroned, with Saint Anne and Five Angels,
ca. 1424.
Tempera su Tela su Tavola.
175 x 103 cm.
Florence, Uffizi.

Like all of Masaccio's work, this picture raises many questions. When was it painted? Was it painted by both Masolino and Masaccio, and if so, did both work on it at the same

time? Whose was the commission? Did Masaccio, who painted the Madonna and child, design the whole picture? Was it perhaps left unfinished by Masaccio, to be completed later by Masolino—perhaps after the former's death? Was it conceived as a single panel, or was the picture originally part of a (projected) triptych? Vasari only mentions it as being in the church of Sant'Ambrogio in the second edition of his *Lives*: was the painting in another church before then, or perhaps not even available to the faithful? Was it painted for the Brancacci Chapel in Santa Maria del Carmine, as has been suggested, but for some reason moved, perhaps after Felice Brancacci's banishment from Florence, in the 1430s?

The picture is known as the *Sant'Anna Metterza*—this last term referring to Saint Anne being *messa terza*, with the Madonna and Christ child in front of her. In this picture, the Madonna and child are enthroned, with Saint Anne apparently sitting behind them on a raised step or platform.

This is such an awkward arrangement that Masaccio can hardly have designed it, which, in turn, suggests that the figure of Anne was an addition either to a simple Madonna-and-Child picture, or a change from a Saint Anne projected by Masaccio, or by the original patron.

There are three smaller figures of angels, above, holding a brocaded cloth with two more at the sides of the throne, swinging incense burners. On the throne is written in Roman letters, the first words of the "Hail Mary"—*AVE MARIA GRATIA PLENA DOMINUS TECVM BENEDIC-TA*. The first five of these same words are repeated in her halo, but in Gothic letters.

Into Saint Anne's halo are punched the words *SANTA ANNA E DI NOS-TRA DONNA FAST*—the *FAST* being ambiguous, but probably meaning "splendor": "Saint Anne is the splendor of Our Lady." In the halo of the angel, probably painted by Masaccio, are Cufic letters.

Like much of the work by Masaccio, the painting shows signs of having been overcleaned.

Most critics agree with the suggestion that the painting is by both Masaccio and Masolino. According to this view, the Madonna and Child, together with the right-hand angel holding the back-cloth, are by Masaccio, while the Saint Anne and the other angels are by Masolino. Some also think that the angel at the very top may possibly be by Masaccio.

There is no question that the painting shows two distinct hands. The manner in which the Virgin's head scarf and robe are painted is sculptured and volumetric, the folds falling naturally.

Her pyramid shape, and solidity, descend from Giotto, while the chiaroscuro used for her face and for the infant are reflective of the San Giovenale painting, but more developed.

The child is particularly sculptural, and must be based upon a common type of statue of ancient Roman babes. The Saint Anne, on the contrary, is wooden and without volume. A comparison of the little hand of Jesus, resting on the Virgin's wrist, perfectly foreshortened, with the left hand of Saint Anne just above it, reveals the enormous difference in the capacities of the two artists. Most critics agree that the painting—Masaccio's part of it, anyway—was executed between the San Giovenale triptych of about 1422, and the Pisa polyptych of 1426.

3

The Brancacci Chapel

ca. 1424–28.
Santa Maria del Carmine, Florence,
Frescoes.

Masaccio painted five of the twelve frescoes in the Brancacci Chapel in Santa Maria del Carmine in Florence, and most of a sixth. Exactly when these were painted and in what order is unknown. Nor is it known why

both Masolino, who also worked there, and Masaccio left the chapel before finishing it, nor whether it was he, or Masolino, or both of them, who had the original commission. Masolino painted three of the twelve extant frescoes, apparently somewhat aided by Masaccio, while Filippino Lippi—in the 1480s—painted three frescoes and part of a fourth, one that may have been left unfinished by Masaccio.

Originally, there were also four evangelists painted in the vault, probably entirely by Masolino, and four other tales from the life of Saint Peter, in the *lunettes* under the vault, probably also by Masolino.

The theme of the chapel, *Scenes from the Life of Saint Peter*, seems to have been painted only rarely, but we know from the extant frescoes of the same theme at San Piero a Grado near Pisa, that those of the Brancacci Chapel were probably fairly traditional. The paintings at San Piero a Grado seem to have been painted by Deodato Orlandi at the beginning of the fourteenth century. Thirty scenes there include eleven of the nineteen scenes originally in the Brancacci Chapel, but not the *Temptation* and the *Expulsion*, which, anyway, are not to do with Saint Peter, nor the *Shipwrecking of the Apostles* (which was in one of the lost *lunettes*), *Saint Peter Baptizing*, *Saint Peter Preaching*, *Saint Paul Visits Saint Peter in Prison*, and the double scene of the *Resurrection of the Son of Theophilus* and *Saint Peter in Cattedra*.

The chapel must have come into the possession of the Brancacci family as Santa Maria del Carmine was being built during the fourteenth century. Although the Carmelites considered themselves the oldest religious order, they seem to have been among the last to build themselves a large church in Florence. This may have been because Carmelite vows of poverty and isolation were originally more strict than those of other "poor" orders. In origin, the Carmelites were purely a contemplative and hermitic order, without establishments in towns. Santa Maria del Carmine was

not finally consecrated until 1422, by which time the city had various large churches belonging to the various religious orders—particularly, to the newer reforming ones. From the large size and number of new churches that had been built by the 1420s belonging to reform religious orders in the city, it's possible to deduce that Florence was avant-garde in this, that the city had a strong bias toward a Christianity that was reformed toward poverty and spirituality. This tendency seems to have existed not only throughout the thirteenth and fourteenth centuries, but on through the fifteenth, right up to the time of Savonarola's death in 1498, and even later. Since the decoration of the chapel didn't begin until after the church's consecration, it's possible that the Brancacci, or the Carmelite monks, felt it incorrect to have a completed chapel in an unconsecrated church. The head of the Brancacci family at the time was an enigmatic figure, a silk merchant who was active in Florentine business and politics. Felice Brancacci was an adventurer and a patriot. He went to Egypt on behalf of the republic and was later also active diplomatically during the Florence war against Milano in the mid-1420s. He seems to have been a friend of Cosimo Medici's, but married a daughter of one of Cosimo's enemies, Palla Strozzi, and was exiled after 1434 by Cosimo. Perhaps Brancacci was a spy for the anti-Medici group, which would have seen in the closeness of the Medici and the papacy great danger for Florentine business and liberty, intertwined as they were. He seems also to have been involved in a fraud involving public funds. Strangely, no reference to the employ of Masolino or Masaccio for the decoration of the chapel in Santa Maria del Carmine has ever been found among the documents concerning Felice Brancacci.

The decoration of Brancacci's chapel seems to have been begun only in about 1425, although the vault and lunettes may have been started a few months earlier, or at least, the planning may have started earlier. The

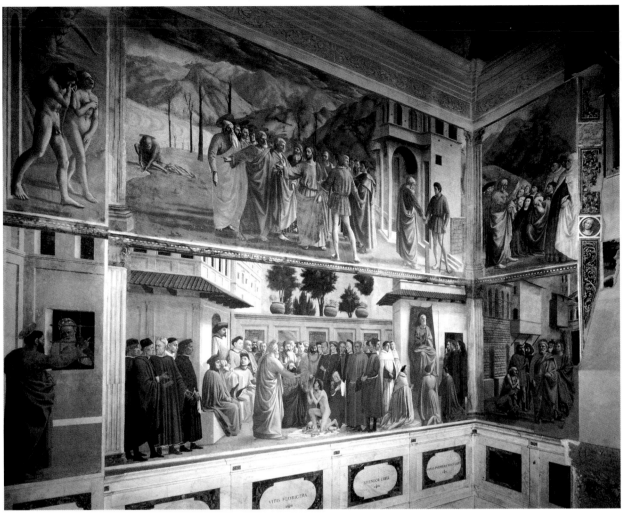

Cat. 3 The left side of the Chapel.

decoration must have been begun by Masolino, who apparently painted the four evangelists mentioned above onto the vault *vele*, and then four scenes from the life of Saint Peter into the three *lunettes*: the *Shipwrecking of the Apostles* and the *Calling of Saints Peter and Andrew*, onto the side lunettes, and the *Pentimento of Saint Peter* and *Christ Consigning His Flock to Saint Peter*, on either side of the window *lunette*. These scenes in the vault area were all destroyed during a remodeling of the chapel in the mid-eighteenth century, some twenty or twenty-five years before a devastating fire in 1771, which destroyed most of the interior of the whole church, but not the Brancacci Chapel. At that time—the

1740s—the window and the altar were both enlarged, destroying the fresco below the window. New decorations were painted then in the vault by Vincenzo Meucci and Carlo Sacconi.

The scenes on the two levels of the chapel's side and back walls are by all the three artists who worked in the chapel: Masolino, Masaccio, and Filippino Lippi. Masolino would probably have continued to work after he'd finished the vault and lunettes, doing the scene on the upper left wall behind and above the altar, of *Saint Peter Preaching*, together with the three scenes on the upper right-hand side wall, the *Healing of the Cripple* and the *Resurrection of Tabita*, and the *Temptation of Adam and Eve*

in Paradise.

Whether he did this before Masaccio began to work, or contemporaneously with him, or even after Masaccio left the chapel, we simply don't know. But it's reasonable to think that Masaccio began to work at this time in the chapel, because it seems to have been Masaccio who painted the houses behind Masolino's scene the *Healing of the Cripple*. It has also been suggested that Masolino and Masaccio exchanged, so to speak, landscape backgrounds in the two frescoes on the upper register, above the altar. Of course, it's possible that Masolino painted only the single scene on the left-hand back wall, leaving to return later to paint the

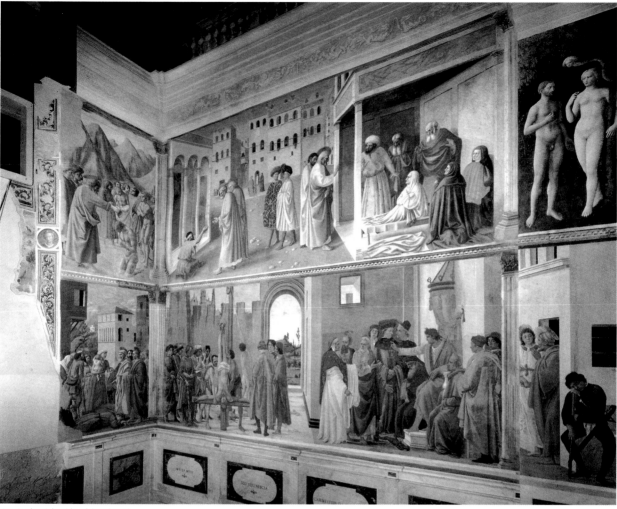

Cat. 3 The right side of the Chapel

upper right-hand wall scenes, although this seems most unlikely.

It's more likely that Masaccio began to paint in the chapel while Masolino was still there, or just after Masolino had left. The various scenes on both levels of the chapel walls are separated by painted classical pilasters that have been designed to give the spectator the impression that he is standing in a pergola looking out past the columns, which hold up the horizontal supports of the pergola, to the spaces where the various scenes are taking place. The space in the pictures is meant to seem to be a continuation of the space in which the spectator stands, and vice versa. Although this may have been

planned from the beginning by both artists, the sophistication of the idea suggests that it was Masaccio's.

Masaccio, then, almost certainly, painted first the scene on the upper right-hand wall behind the altar, *Saint Peter Baptizing*. He would probably have followed this by painting, on the same level, the *Tribute Money*, and then the *Expulsion*: the reason for supposing this sequence is that on the lower level of the same wall, Masaccio completed *Saint Peter in Cattedra*, but not (unless it was later destroyed) *Saint Paul Visits Saint Peter in Prison*, suggesting that the painter worked from right to left. He also seems to have worked from right to left in the central section of the *Tribute Money*.

Originally, the window of the chapel—as noted above—was not so large. Below it, and above the original fifteenth-century altar, was quite a large piece of wall, which also was painted. From fragments left of this painting, it has been suggested that the scene was the *Crucifixion of Saint Peter*. But since Filippino Lippi, when he completed the chapel in the 1480s, painted this scene on the right-hand wall, it seems unlikely that the scene already existed in the chapel. More likely, the picture above the altar would have been one of the other episodes painted at San Piero a Grado.

The scaffolding would have been lowered, and whoever painted this

now-destroyed scene or scenes on the wall behind and above the altar would have probably done this next, as the scene extends between the levels of the two registers. Then Masaccio would have finished that wall, by painting the two scenes on it, on the lower level to the left and to the right of the altar: *Saint Peter Healing with His Shadow*, and the *Distribution of the Goods of the Community and the Death of Ananias*.

What happened next is more than usually problematic: the whole right-hand wall in the lower register was painted by Filippino Lippi in the early 1480s. What was on the wall before he began to work is unknown. It's possible that either Masaccio or Masolino had made a start of some sort either with sinopia drawings, or even with fresco, but it's generally assumed that there was nothing on the wall at all—if not drawings—when Masaccio and Masolino left the chapel permanently. Felice Brancacci refers to the chapel in his will of 1432 as incomplete.

The left wall with the three scenes of *Saint Peter in Cattedra* and *The Resurrection of the Son of Theophilus*, and *Saint Paul Visiting Saint Peter in Prison*, is also very problematic. Masaccio painted the whole of the right-hand section, with *Saint Peter in Cattedra*, surrounded by civil (including, apparently, Masaccio's own self-portrait) and religious figures plus all the upper architectural section of the *Son of Theophilus* scene. But he did only some of the figures there—Theophilus himself, and some of the figures near him, including Saint Peter, but not the resuscitated boy. It has been suggested both that Masaccio never finished all the figures, and that he did finish them, but some of them were destroyed. We simply don't know what happened.

In the 1480s, Filippino Lippi completed what must by then—if there were figures that had been canceled—have been missing from this lower left-hand register, including the whole pilaster scene *Saint Paul Visiting Saint Peter in Prison*. At that time, Filippino also painted the whole lower register

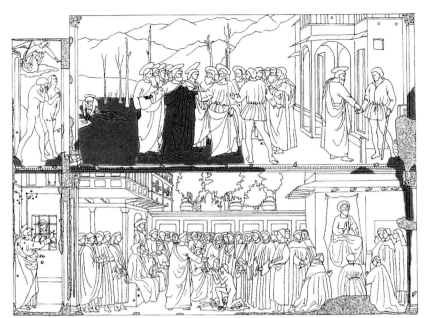

of the right-hand wall—the three scenes of the *Crucifixion of Saint Peter* and *Saint Peter Disputing with Simon Magus before Nero*, and, on the entrance pilaster, *The Liberation of Saint Peter from Prison*. When the altar was dismantled during the restoration of the 1980s, some fragments of decoration were found behind it, including two heads that seem to be by Masolino. These have been left *in situ* and are now visible (Cat 3). These two heads present us with another problem: was it Masaccio or Masolino who painted the now-destroyed scene above the original altar, and when?

Vasari describes the paintings by Masaccio much as they are today. But later in the early seventeenth century, as mentioned, there was a remodeling of the chapel that included an enlarged altar. At the end of that century, there was a suggestion that the whole chapel be redecorated. Wisely, the then-ruling Medici Archduchess, Vittoria della Rovere, forbade this. However,as mentioned above, in the 1740s, the chapel's ceiling window and altar were again remodeled, destroying the vaults, as well as the fresco that had been painted behind and above the original altar. As also already mentioned, there was a vast fire in the Carmine church in 1771. Luckily, the

Brancacci Chapel was spared, although the heat would have been deleterious to the frescoes. Shortly after the fire, the *patronato* of the chapel changed from the Brancacci to the Riccardi, who restored the chapel at that time. All through the post–World War II years, there were suggestions that the frescoes might be cleaned, but Lionetto Tintori, then the greatest expert on fresco restoration, who had cleaned many of the most important fresco cycles in Italy including Masaccio's *Trinity*, was hesitant. He didn't think that restoration was absolutely necessary, and he was wary of hurting pictures that are so crucial to the history of art. In the 1980s, a long restoration took place, financed by the Italian business-machine firm Olivetti, under the technical direction of Umberto Baldini, an art-historian, and Ornella Casazza, a restorer. The cycle of frescoes, *Scenes from the Life of Saint Peter*, painted, as they were, at a moment of great crisis in the history of the Church, are likely to have, as commented earlier, a political meaning, as well as the obvious religious one. There have been various suggestions to this effect, including one that the fresco refers to the struggle between Florence and Milano, and to the Church's role as mediator in those troubles.

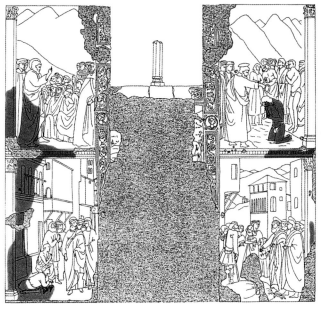

Cat. 3 [on left] *Sketch drawings of the Walls of the Brancacci Chapel showing what was damaged during the the fire of 1771.*

Cat. 3 [on right] *Maso-lino and Masaccio (?) These two heads – one masculine, one femminine – were discovered in the 1980's during the restoration of the Brancacci Chapel. The female head is clearly by Masolino, while the male one could be by Masolino under the influence of Masaccio, or Masaccio imitating Masolino.*

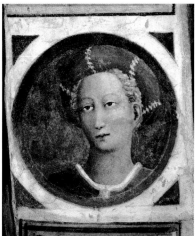

Considering that the figure of Saint Peter must represent the Church, and considering the history of the Church in Florence in the decades before these frescoes were painted, when during the War of the Eight Saints against the papacy, not only was the whole of Florence—one of the three or four biggest and richest cities in Europe—and all Florentines everywhere, placed under interdict (as were even those who traded with Florentines), and considering in general the whole miserable history of the Great Schism of 1378–1417, it would be interesting to know the precise attitude of Florentine Carmelites and of the Brancacci toward the return of the papacy to Rome in 1420. Santa Maria del Carmine was one of a number of huge churches built in Florence during the fourteenth century by groups that advocated a poorer, stricter Christianity, and an imitation of Christ and the apostles. In the Brancacci Chapel, both Saint Peter and Christ appear poor and unadorned, ordinary human beings, in a world where the papacy had a reputation developed over many, many decades for luxury, corruption, and thirst for temporal power. After forty years of schism, with the election of four different lines of claimants to the pope's throne, the papacy also had an

aura of decay, disintegration, and even inconsequence.

The appearance in the Brancacci Chapel of a humble, human figure of Christ telling Saint Peter—equally ordinary and poor—to pay tax to the state is unquestionably a political message. And the appearance in the fresco below the *Tribute Money* of a civil ruler carrying a staff of authority, looking across at an unadorned *Saint Peter in Cattedra*, praying, again suggests a strong political undertone to the fresco, particularly as Masaccio's own (apparent) self-portrait looks out at us.

It has been suggested that the *Tribute Money* refers to the Florentine *Catasto* tax of 1427, a sort of income tax levied on all, and that some of the figures in the *Resuscitation of Theophilus's Son* are political figures of the early fifteenth century. Other interpretations have been suggested for various scenes in the chapel. As remarked earlier, it may also be possible that Masaccio's work is antipapal in tone, and that the *Tribute Money* points out how a church that should be humble and poor should pay tribute to the state.

If this were true, then the scene *The Resuscitation of Theophilus's Son* may even be more incisively political. If

the onlookers surrounding the resuscitated boy were all meant, as seems possible, to be figures in recent Italian history and politics, then perhaps—since it was such an issue for early Renaissance Italy—these may be persons who supported the idea of Italian unification as a single nation-state. Saint Peter's act of resuscitation would, if this were the case, refer to the capacity of the Church by submitting at that delicate point in history, to civil authority, to resuscitate the Italy of Roman times, a single country. After all, the papacy had been absent from Italy, either in Avignon or elsewhere, for much of the fourteenth and for the first two decades of the fifteenth centuries. This absence had contributed enormously to the economic and social

development of Florence and other Italian cities. Also, as pointed out earlier, if the *sinopias* for the two frescoes on the right-hand wall were already drawn out in sinopia by Masaccio or Masolino, and were the drawings used more or less by Filippino, the fact that the scenes refer to simony, and to Peter's willing crucifixion after having met Christ while leaving Rome, would support an antipapal interpretation.

The six scenes by Masaccio in the Brancacci Chapel are:

a) Saint Peter Baptizing
Fresco. 247 x 172 cm.

In each of the scenes painted by Masaccio, Saint Peter appears differently. Here, he is like Masolino's fresco *Saint Peter Preaching* on the opposite wall, suggesting that, at this point, the two artists were trying to synchronize things. This would be strongly reinforced if the suggestion that in this scene Masolino did the mountains behind, while Masaccio did those in *Saint Peter Preaching*, were correct. The two figures behind Saint Peter are certainly portraits, and very similar.

One of them is probably Felice Brancacci. Since they are by Masaccio, they can be fruitfully compared with three portrait heads sometimes attributed to Masaccio in Boston, at the Gardner Museum in Chambery, at the Beaux-Arts and in Washington, D.C., at the National Gallery (*Cat. A8-10*).

Vasari points out that the two almost-nude figures of neophytes had, even then, always been remarked upon for the stunning realism with which they are painted, presumably the first nudes painted from life and anatomically correct in Europe. If they are, Masaccio begins a tradition of painting life-nude studies in European art that continues to this day.

b) The Expulsion
Fresco, 214 x 90 cm.

This fresco, with the one opposite by Masolino of *Adam and Eve Tempted in*

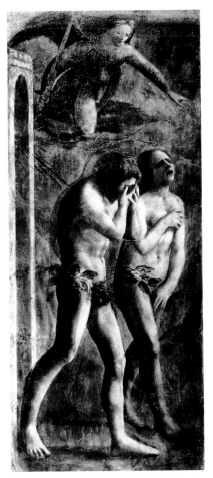

Cat. 3b The Expulsion of Adam and Eve from Paradise before its recent restoration.

Paradise, would seem to introduce the central idea behind the scenes in the chapel: humanity fallen from grace and expelled from paradise because of sin can regain goodness and happiness through the Church. The picture owes much to ancient sculpture. Eve seems to be modeled on one of the many statues of Venus *pudica*, while Adam's head, agonized face, and body pose also all seem to stem from classical models. Masaccio's composition, especially of the two figures of Adam and Eve, is so similar to the same scene by Jacopo della Quercia for the Fonte Gaia in Siena, finished about 1419 or 1420, that it suggests that Masaccio knew the sculptor.

Until the cleaning of this fresco in the 1980s, Adam's and Eve's thighs and private parts were covered by leaves

painted *al secco* over the *al fresco* work. As noted before, this painting's dramatic intensity has been considerably changed by the cleaning, particularly by the lightening of the darker passages, cast shadows, and by a considerable change in color relationships.

c) The Tribute Money
Fresco. 247 x 597 cm.

There are three episodes in this one painting, which is based upon the Gospel of Saint Matthew 17:24–27. Christ, in the center, tells Saint Peter to go to the sea (here, presumably a lake), where he'll find a coin in a fish's mouth. Peter does this on the left. On the right, he pays the tax collector at the entrance to Carparnaum. It should be noted that Saint Peter has two quite different heads in this painting, but both are apparently copied from classical models. Also the trees in the background, which in early copies of the painting are leafed, have lost their leaves. Probably, Masaccio painted these *al secco* and they have all—so to speak—fallen off.

The picture is exceptional for its non-Gothic architecture shown in perspective, for its magnificent scene of nature and space, the lake, and the distant mountains dominating the scene, for the sculptural figures with their classical statuesque stances, togas, and heads, for the new sense of true space, distance, atmosphere, and possible movement of man, and for the colors: particularly, for the large band of almost abstract color that the cloaks of the apostles make across the central part of the painting, giving a sense of movement, drama, excitement, and joy. Above all, the picture is unique for the apparent light in it, which seems to stream into the fresco from the right, as though from the window. This unifies everything in the picture and seems almost miraculously to include the spectator standing in the chapel in the same streaming light, and the same apparent space of the picture. This picture, together with

the *Trinity*, forms the basis of Florentine art, centered as it was to be on nature and on man—and even of all European art—for the next four centuries. It may have, as pointed out above, reference to the Florentine tax system, or to contemporary church-state relations.

d) Saint Peter Heals with His Shadow

Fresco. 232 x 162 cm.

This scene is on the lower register behind the chapel's altar, and to the left of it. Saint Peter (again, different from most of the other Saint Peters in the chapel but almost identical to *Saint Peter in Cattedra*) walks along a street in a medieval town like Florence, his shadow healing the infirm as he passes. It has been suggested that the windows in the first building on the left resemble those of Palazzo Pitti (which would not have been in 1425), while the column and church in the background may be the piazza and church of San Felice, in Florence. Various identities have also been suggested for the figures with Saint Peter: Masolino, Donatello, Masaccio's brother Giovanni. It has also been worked out that this fresco fits into a single one-point linear perspective system with *The Distribution of the Goods of the Community and the Death of Ananias*, on the other side of the altar. This must be one of the earliest scenes in European art where convincingly portrayed human beings are walking through a convincingly portrayed city street.

e) The Distribution of the Goods of the Community and the Death of Ananias.

Fresco. 232 x 157 cm.

Ananias and his wife Saffira were members of an early Christian community. When any of the community's members sold anything, they were supposed to bring the entire sum realized, so that it could be distributed fairly among the members of the community. But after Ananias and Saffira had sold something, they se-

cretly kept for themselves part of the price. Saint Peter, however, knew, and asked Ananias why he'd done that, at which point Ananias dropped dead. When Ananias's wife and accomplice, Saffira, appeared, Saint Peter also questioned her. She lied. Saint Peter again showed that he knew, and she also dropped dead. Masaccio's scene shows Saint Peter with Saint John next to him, distributing the goods of the community. At his feet is the dead Ananias. The painting shows Masaccio's great ability to create seemingly real people in a real space, even one hemmed in by buildings. Behind the marvelous architecture, the mountains rise up steeply. The white castle could be a reference to the similar Castellani family castle near Reggello, which Masaccio would have known well. This painting is developed within the same one-point linear perspective system as that of *Saint Peter Healing with His Shadow*, that is, the space created in both pictures fits into the same system, as though both scenes were taking place in the same world. There have been suggestions that there is, here also, a political reference in the Ananias story to the *Catasto* tax in Florence. But the fact that this scene appears also in San Piero a Grado, more than a hundred years earlier, would seem to weaken the argument.

f) The Resurrection of the Son of Theophilus and Saint Peter in Cattedra.

Fresco. 232 x 597 cm.

These two scenes are part of the same fresco, on the lower left-hand wall of the chapel, under *The Tribute Money*. Theophilus was the governor of Antioch, in what was then Syria. He put Saint Peter in prison, but was persuaded by Saint Paul to let Peter out, if Peter could bring Theophilus's son, dead fourteen years, back to life. Saint Peter did this. So the governor himself, and many others, converted to Christianity. Theophilus then gave his own house to be made into a church. In it, he made a raised

cattedra for Saint Peter, so all could see and listen to him.

The fresco is interesting for many reasons, not the least of which is that there appears to be a self-portrait of Masaccio just to the right of *Saint Peter in cattedra*, looking out at us, together with figures who may be Masolino, Leon Battista Alberti (or Donatello), and Brunelleschi. The fresco as it is today was painted by both Masaccio and Filippino Lippi. All the right-hand part, with Saint Peter praying *in cattedra*, is by Masaccio, including the three Carmelite monks to the left of him, and the one face to the left of those three monks. Of the kneeling monks at Peter's feet, two of them clearly show the tonsure, a sign of commitment (recounted in the *Leggenda Aurea*, of which the painting is an illustration) to purity, renunciation of the world, and closeness to God.

Masaccio must have done all the architecture and trees, right down to the line of heads across the center of the picture. He also painted all of Theophilus in his niche, the figure seated below him, plus the whole of the figures between him and the standing Saint Peter. Masaccio painted the second head to the left, but not the first. He did not paint below those two heads, and, in fact, the second head to the left with the beret (which has been tentatively identified as Cardinal Branda Castiglione) has no feet. Masaccio also painted Saint Peter and the seven faces to the right—that is, including the face of the man with a necklace, but not the kneeling figure, and certainly not the son of the governor. These, plus the eight figures to the right of the man with a necklace, and those to the left of the head with no feet, were painted by Filippino Lippi when he completed the painting in the 1480s.

The painting is also interesting for the bright architectural background, which is the governor's house in the story, in its one-point perspective system, then a completely new architecture with no traces at all of the medieval Gothic world. It could also be said that Brunelleschi helped

Masaccio with this architecture, but the suggestion would seem weak. Presumably, this shows that Masaccio was potentially a fine architect, even a great one. The governor's *palazzo* hardly shows any influence of even early Renaissance architecture. Incidentally, the placement of the heads before multicolored panels on a wall is a direct forerunner to Castagno's striking use of the same device in his magnificent *Last Supper* at Saint Apollonia.

It has been suggested, as mentioned earlier, that various of Masaccio's figures are portraits: that, for instance, Theophilus is the Milanese leader Giangaleazzo Visconti, who tried to conquer the whole of Italy and thus unify it, while the sitting figure below him may be Coluccio Salutati, the Florentine chancellor for many years, and Salutati's enemy. The monks around Saint Peter are presumably Carmelites in Santa Maria del Carmine in the 1420s. It should be pointed out that Vasari says that the heads by Filippino Lippi are also portraits, and writes who some of them are supposed to be.

No one knows why Masaccio didn't finish this painting, or why, if he did, some of the figures were removed to be later replaced by ones by Filippino Lippi.

But certainly, most of the extant heads by Masaccio (at least fourteen of them, without counting Saint Peter) seem to be portraits. So it's logical to presume that the missing heads were to have been portraits by Masaccio, or were portraits that were removed.

The question is, who are the extant portraits by Masaccio, and who would have been those removed or never painted?

If the painting has a political meaning beyond the religious one, as it presumably does, since it's clearly about temporal power and spiritual power, and how the Church through its spiritual powers can help build a Christian state, then perhaps all the portraits are meant to have been people who bear witness to this idea. One of the principal hopes of many

early fifteenth-century Italians was that Italy, with the tremendous wealth and freedom it had, with its future open to many great possibilities, could, like other European states were doing just then, unite to become once again, as it had been in classical times, a single powerful country, a new Rome. But for this to happen, it was essential that the papacy—just returned to Rome six or seven years previously, after the worst crisis in Church history, and after either a spiritual or a physical absence from Rome, or both, over a century—support the effort.

Certainly, many local organizations, both religious and lay, all over Italy, hoped for such an event.

The scene *Saint Peter in Cattedra*, clearly representing the Church, surrounded by artistic and religious supporters, with a civil authority looking on, witnessed by many well-known figures, a scene where religious power is put at the disposal of secular power, for the good of all, may well be about this new hoped-for society of the future.

4

The Pisa Polyptych
1426
Tempera on cloth on panel.
ca. 300 x 2.30 cm

Various reconstructions have been proposed for the large altarpiece Masaccio painted in Pisa, apparently during most of 1426.

The contract was signed by Masaccio and Ser Giuliano di Colino degli Scarsi da San Giusto, on 19 February.

Following this were eight payments between 20 February and 26 December, at which time the picture must have been more or less completed.

Vasari describes it *in situ* in both his 1550 and 1568 editions, so it was dismembered at some later date.

There are eleven extant panels:

a) The main panel, the *Madonna and Child Enthroned*, with four angels, now in London's National

Gallery. 135 x 73 cm.

b) A panel of *Christ on the Cross with Saint John, Mary His Mother, and the Magdalene*, now in the Capodimonte Museum in Naples. 83 x 63 cm.

c-d) Two predella panels by Masaccio: the *Adoration of the Magi*, which must have been under the central panel; and another, a double scene, of the martyrdoms of *Saints Peter and John the Baptist*, which was under images of Saints Peter and John the Baptist to the left of the *Madonna and Child Enthroned*.

These two panels are now in the Staatliche Museen in Berlin. Both 21 x 61 cm.

e) Another predella panel, probably from the right-hand side of the picture, with *Saint Julian Murdering His Parents*, and *Saint Nicholas Throwing the Golden Dowry to the Unwed Girls*.

This third predella seems to be by an assistant to Masaccio. It is also in the Staatliche Museen in Berlin. 22 x 62 cm.

f) A panel of *Saint Paul*, now in the Museo Nazionale, Pisa. 51 x 30 cm.

g) A panel of *Saint Andrew*, now in the J. Paul Getty Museum in Malibu, California. 51 x 31 cm.

h-k) Four small panels of saints, all now in the Staatliche Museen, Berlin: *Saint Augustine*, a *Carmelite Saint*, *Saint Jerome*, and another *Carmelite Saint*. Each 38 x 12 cm.

Vasari writes quite clearly that the Virgin and child in the Pisa altarpiece are flanked by Saints Peter, John the Baptist, Julian, and Nicholas.

So these figures would have been above their respective predella scenes, while the Magi scene, as noted above, was under the Madonna and Christ child. All the four main figures of saints are lost, so we don't know whether there were four separate panels, or two panels, one each side, with two saints on each.

The placing of the four small identi-

Cat. j-k Saint Gerolamo and a Carmelite Saint

level of saints, would have been about four meters above the ground level and may have been nearly five, which is why Masaccio has painted Christ's head so neckless: it would have seemed natural that way, seen from two or three meters directly below.

Nor is it known exactly where in the Carmelite church in Pisa was Ser Giuliano's chapel, although the suggestion that it was built against or into a previously existing rood screen seems reasonable. In any case, wherever the altarpiece stood, it would have had a strong light source to the left of it.

As Masaccio was such an innovative painter, and the form of Ser Giuliano's altarpiece so traditional, there has been some discussion on whether the saints were arranged as though in the same space as the Madonna and child, without any separation between the main panel and the saints' panels (in the manner of the later *Sagra Conversazione*), or whether there was some sort of traditional division—such as colonettes—between the Madonna and the saints.

At this point, there seems to be no way of knowing for sure. Vasari doesn't remark on the central composition as being unusual, or innovative, suggesting that perhaps it wasn't.

Masaccio would probably have wanted a single space—if we go by his own San Giovenale triptych, and the altarpiece of Gentile da Fabriano for the Strozzi, now in the Uffizi, as indications of the way altarpieces developed in Florence in the 1420s.

But Ser Giuliano and the Carmelites may have wanted a traditional construction with colonettes separating the panels, and may have insisted Masaccio work within that form.

The four most interesting panels from this dismembered altarpiece are the central *Madonna and Child*, of course, the scene *Christ on the Cross*, which was originally above it, and the two predellas of the *Adoration of the Magi* and the *Martyr-*

cal-size panels of saints now in Berlin, could also have been either across the top of the altarpiece or down the sides.

The *Crucifixion* was certainly above the *Madonna and Child*, but there may have been figures of other saints, now lost, between the two pictures. Probably the two extant panels of *Saint Paul*, still today in Pisa, and the *Saint Andrew*, now in

Malibu, were to the left and right of, and slightly lower than, the *Crucifixion*.

In any case, the picture stood on the back of an altar, and would have completed a large complex. The Madonna and child are on a throne, the seat of which is slightly above the spectator's eye level. This means that the *Crucifixion* panel, even without an intermediary

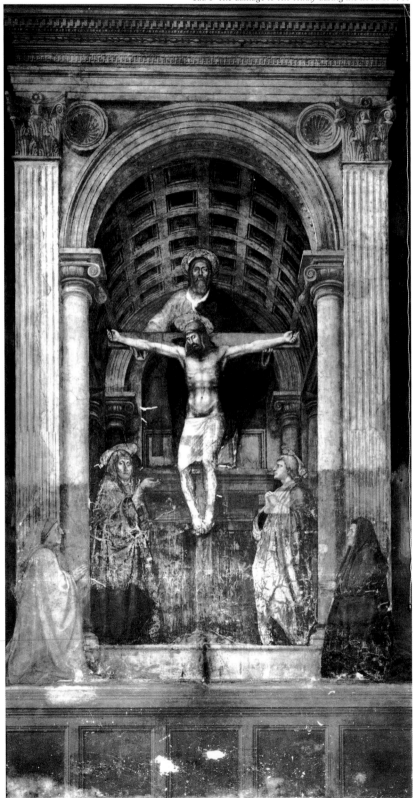

dom of Saints Peter and John the Baptist.

In all these, Masaccio has greatly developed a single strong light source as the unifying element.

The light comes from the left and casts strong shadows throughout these four pictures, enriching their colors to powerful hues.

The painter, using a strong chiaroscuro or modeling, develops his figures standing freely in space, with an independence and sense of reality, and a calm sureness that has absolutely never appeared in Florentine painting previously.

The naturalness of the horses, the fineness of the portraits—perhaps of Ser Giuliano and a brother?—the dynamism of the two executions, the pathos of the red and yellow wailing Magdalene, the delicacy of the angels playing music and the monumentality and humanity of the Madonna and child are all elements carried to a scale never before seen.

In this painting, Masaccio not only clearly indicated the direction that painting would follow, of drama and so-called realism, and particularly of close observation of nature; he also set standards that painters would strive at length to equal, but would rarely manage to surpass.

5

The Trinity
ca. 1427.
Fresco.
667 x 317 cm.
Florence,
Santa Maria Novella

This large fresco has had harsh treatment and shows it. More or less none of the edging is original, while four areas within the picture have been repainted.

A thorough excellent restoration was made about 1950 by Lionetto Tintori, and a second absolutely uncalled-for, commercially oriented restoration was thwarted in 1992 by Masaccio scholars.

This is a very old, very, very pre-

cious, and very damaged work of art. It should be left as undisturbed as necessary for its survival.

It was almost certainly painted toward the end of Masaccio's short life, perhaps even as late as the winter of 1427–28, or even the spring of 1428, before Masaccio's presumed fatal trip to Rome.

There are about twenty-eight *giornate*, so even with any secco work that the painter will have applied after the fresco itself was finished, the picture took, probably, less than two months to paint.

Its complexity suggests that the picture was meticulously planned, perhaps even while Masaccio was working in Pisa during 1426.

Together with the *Tribute Money*, this painting sets the main basis not only for Renaissance paintings' search in space and light, and in volume and shadow, for new idioms; because of its rigorous one-point linear perspective, in many ways it also precludes all European painting until the time of Cézanne.

The scene is of the Trinity—God the Father, the Holy Spirit as a dove, and Christ tranquil on the cross. But of course all three, in Christianity, are One: so God the Father is also Christ, risen from the dead, and Christ is God the Father. The Virgin stands on the left below, and opposite her, Saint John on the right. Although the arrangement of the *Trinity* in this manner is fairly traditional (there are dated examples by Mariotto di Nardo from 1398 and 1406, and by Lorenzo di Niccolo in 1402, as well as one from 1365 by Nardo di Cioni), all these figures are most unusually inside what can only be a sepulchre, with God the Father standing on a ledge in front of the tomb itself. The sepulchre is a magnificent Renaissance construction done in such an illusionistic way that the wall seems truly pierced by the barrel vault and the deep chamber. Just outside, kneeling on a ledge, outlined against the apparently massive Corinthian pilasters are the two donors, praying, one in

red, one in black.

This color motive, signifying passion and death, is used back and forth across the surface of the picture, while the inside, so to speak, of the mausoleum is almost gray.

The architecture outside has a more brown or slightly cream color, while Christ, standing out, will have been originally a brilliant, glowing white. Below the two donors is an illusionistic painting of an open wall-tomb, next to which is a skeleton on a sepulchre. The sepulchre is painted as though it lies under an altar supported by four colonettes. On the back wall of the tomb is written in Roman characters: *IO FU GA QUEL CHE VOI SETE: E QUEL CHO SON VOI ACO SARETE.*

The fresco was covered up, in the 1550s, by a large stone altar, together with a canvas painting by Vasari. This painter seems to have taken great care not to damage Masaccio's work. In the mid-nineteenth century, the picture was rediscovered, detached from its original wall, and somehow carried down the nave to the interior wall of the façade, where it was reattached. There it remained, suffering further damage from the changes of temperature that nearness to the entrances caused, until 1952. It was then moved back again to its original site, and reunited to the grisaille fresco of a skeleton that had been separated from it, and left behind on the first trip. No one has ever been able to show definitively whether there was a stone altar slab, positioned on colonettes like the two painted illusionistic ones, which seem to hold up an altar at either end of the skeleton's tomb. And if there were originally two real colonettes, why did Masaccio paint illusionistic ones as well?

The original aspect of the painting is a further puzzle because of the position of the two donors. They are painted, and thus part of the picture.

But they are also painted kneeling outside of the main section of the picture, on a step that seems to rest

on the altar, as though they were the half-solid, half-spiritual link between the altar outside the picture, where Christ is reborn at each mass, and the heavenly world of the inside of the chapel, with the magnificent triple deity.

Certainly, a full altar would have somewhat broken the illusion of the pictorial space that Masaccio has created, whereas an altar slab, only a foot or two deep—just wide enough to be used for the mass—would have heightened it, perhaps with a single set of thin colonettes, set slightly wider than the widest painted ones.

There was an old Christian legend that Christ's crucifixion would be on a cross made of wood of a tree that grew from Adam's dead body. So the reference here, with its chilling inscription, "I was that which you are, and what I am you will be," seems to be referring directly to the most sacred truth of Christianity—Christ's Resurrection and our Redemption. This would fit well into the significance of the feast of Corpus Domini—a celebration of Christ's humanity, the feast for which the picture seems to have been made. Although the picture has always—since Vasari called it so—been the *Trinity*, this reference to Christ's rebirth through us and for us, coupled with the gentle manner in which God the Father holds up Christ's weightless body and cross as though an offering, is to the Eucharist.

The feast of Corpus Domini is a celebration of the evening before Christ's death, when he instituted the Sacrament of the Eucharist. Through this, in Christian belief, he gave the apostles the power to recreate his flesh and blood, so that all Christians can eat these, and be saved.

The picture is placed above an altar, as though an integral part of it—the altar being a symbolic stepping-stone from this world to that of salvation. Adam's—and our—body is below, in this world. Christ's is above, in the other. Mary, who rep-

resents the Church, the heir of the apostles, gestures toward Christ's crucified body in that other spiritual world. The Mass that resurrects Christ in our world gives him to us to eat.

Through the Christian doctrine of transubstantiation, the bread and wine become, in fact, the true Christ–God–the–Father we see beyond the altar, in the sepulchre.

So the Resurrection we see painted by Masaccio is given its meaning in the Mass said before it. God the Father and we, together in the Mass, simultaneously offer up the body of Christ for our Redemption.

It has often been suggested that Filippo Brunelleschi (1377–1446), the great Renaissance architect and contemporary of Masaccio's, helped Masaccio design the magnificent Renaissance architecture in this remarkable painting, or even that he designed it himself.

Certainly, in 1427, when Brunelleschi would have been about fifty years old, the architect had already made arches similar to this, although without the barrel vault and coffering we see in Masaccio's painting. It is likely that they collaborated in this picture.

But the suggestion, it seems to me, has also to be considered with great care.

This picture is by one of the greatest painters who ever lived, a great thinker and revolutionary. Like the *Tribute Money*, this picture is one of the most profound and basic statements of the new vision of life that was just then appearing.

We know from the San Giovenale triptych that already by 1422, some five or six years earlier, Masaccio understood, even if in rudimentary form, one-point linear perspective.

We know from the Brancacci Chapel that he was capable of imitating the antique, as well as of putting architecture—even modern architecture—into perspective.

Masaccio would have gone to Rome in his late teens or early twenties, perhaps with Brunelleschi and maybe also with Donatello, to study Roman sculpture and precisely, Roman architecture. He would probably have done drawings of the coffering in the Pantheon and in the various baths, as well as of the triumphant archways. The theology of this picture couples the flesh and blood of Christ inside the picture, with the flesh and blood of Christ—in the form of bread and wine, while on the altar during mass—outside the picture.

An equally complex, immaterial spatial construction joins the material and the spiritual worlds, so that they, too, flow in a parallel manner, one into the other, without barriers. To suggest all is not under the command of Masaccio's genius is perhaps to belittle the painter unnecessarily.

It is probable that Masaccio was aided by Brunelleschi in the design of the architecture. But perhaps also Masaccio designed the architecture himself, and worked out all the perspective.

Such a feat would not have been beyond his genius. More we cannot say at this point.

This one painting sums up the core of Christian belief as it has always been—the Resurrection of Christ and the Redemption of man.

But it casts this belief in an idiom so revolutionary that in a sense, it also terminates its medieval form, while clearly indicating the new Renaissance form. The painting attempts to take—and to a great extent, succeeds in taking—Christianity's profoundest doctrine out of the medieval world of symbolism, and bring it into the concrete world of nature.

Masaccio may have turned to Brunelleschi's *Crucifix* then, as now in Santa Maria Novella, as a model for his own Christ.

This has been suggested. Or he may have been influenced by one attributed to Michelozzo, which may, in fact, be by Donatello or perhaps by Nanni di Banco, now in San Niccolo Oltrarno: this latter has a face and a body structure similar to Masaccio's Christ. If Masaccio had done sculpture, he might well have produced a Christ Triumphant such as this.

There was also a theologian—Alessio Strozzi—at Santa Maria Novella, who may have helped Masaccio with the combination, in the *Trinity*, of profound Christianity and profound reality.

Who commissioned this fresco is unknown, although the two figures painted as kneeling outside the chapel are presumably portraits of the donors.

The female figure is presumed to be the wife of the donor. Two names are usually put forward for the male: Lorenzo Cardoni, prior of Santa Maria Novella from 1423 to 1425; and Domenico Lenzi, one of the *gonfalonieri* of Florence in those years.

Since the prior was probably not married, this couple may, of course, be relatives of his. But the choice of Domenico Lenzi and his wife is more likely, especially as his tomb, with the date 1426, was once near the picture.

6

**Saint Jerome
and Saint John the Baptist.**
Tempera on cloth on panel.
114 x 45.5 cm.
London,
National Gallery of Art.

Vasari describes visiting the church of Santa Maria Maggiore in Rome with Michelangelo and admiring the triptych this panel comes from. On each side of the central panel, he writes, "were two saints, and in the middle Pope Martin V, who is tracing the foundations of the church with a spade, and near him is Emperor Sigismund II." It's strange that Vasari doesn't describe the verso of the triptych, also painted. But it may be that the painting was at that point only viewable from one side, having been, for instance, placed against a wall. On the other side, the central panel depicted *Mary in Glory Surrounded by Angels, with Christ above*, and four

saints, two on each side, in the side panels.

Later, at some point, the triptych was sawed in two ways, so that six separate pictures resulted: the central panel and the side panels were parted, then each of these was cut through its thickness, resulting in six separate pictures. Five of these are by Masolino, the two central scenes front and back, and three of the four side pictures. This panel, of *Saints Jerome and John the Baptist*, is the only one by Masaccio. It must have been on the front, and to the left of the main scene.

Now in London's National Gallery, the two central scenes are today in the Capodimonte Museum in Naples; the four verso Saints Paul and Peter, and Saints Martin and John the Evangelist are in the Philadelphia Museum of Art, while the other two recto saints, Saints Matthias and Gregory, are also in London's National Gallery. Pope Martin V, who seems to appear not only as Saint Martin in the painting, but also as Saint Liberius in the central panel, was a member of the Colonna family, which was particularly connected with Santa Maria Maggiore. Cardinal Rinaldo Brancacci and Branda Castiglione were also connected with the church, and so, presumably, any one of the three—or someone else—may have commissioned this picture.

Since Masolino worked for Branda Castiglione both in Rome and at San Clemente, and at the cardinal's home in Lombardy, he is obviously the most likely candidate. But Martin V, of course, may have commissioned the picture himself.

No one seems to agree on a possible date for the painting, nor why one panel is by Masaccio and five are by Masolino.

One strong possibility is clearly that Masaccio worked on the triptych in Rome in 1428 before he died, and that Masolino finished it later. But there are many opinions on the correct date, where it was painted, and for whom. There are even critics who believe that none of the panels is by Masaccio.

Attributed Works

I. The following are those most often discussed in lists of Masaccio's work as possibly being by him:

A1

Desco
da Parto
tempera on cloth on panel,
Berlin,
Staatliche Museen,
56.5 cm in diameter.

Many critics think this painted tray is by Masaccio.

The cropping of the architecture at the edges of the painting, the rigorous, highly developed perspective with its remarkable chiaroscuro, the sense of a single unifying light, the unity of action, the frank reality of the iron ties holding the front columns together, the birth tray within a birth tray, the two Florentine banners beautifully, differently painted, the sense of music and celebration emitted by the puffed cheeks of the trumpeter, the calm green of the grass with the subtle cut in the wall, the simplicity and intimacy of the bedroom contrasted with the large cloister, and many other elements suggest a master of brilliant psychology, and a great innovator. Who else might have painted this?

On the reverse is a nude babe with an animal.

Presumably, this is the newborn child of the recto, a bit later, with a much-loved pet, painted by an imitative hand.

Cat. A1 verso.

A2

Madonna and Child
(the so-called Casini Madonna)
tempera on cloth on panel,
Florence, Uffizi,
24.5 x 18.2 cm.

The attribution to Masaccio is based on both the Masaccesque character of the Virgin and child, and on the arms, apparently of Cardinal Casini, painted on the verso. But the quality of the painting, as well as other disturbing elements, make the attribution problematic.

A3

The Crucifixion
fresco,
San Clemente, Rome.

This large wall painting has suffered over time. So what is now there must be treated with caution. But there are elements in the work, especially in the sinopia, which suggest that Masolino (to whom the Chapel of Saint Catherine in San Clemente is attributed) did not execute all entirely by himself. In particular, the horsemen on the lower left, and the extensive, rolling· landscape with Christ as though hanging high above it, seem unlikely to have been conceived by Masolino.

This is also true for other passages in the chapel, particularly the *Annunciation* on the outside of the entrance arch.

Since the chapel may not have been completed until after Masaccio's death, it's possible that someone else aided Masolino, but the assistants available in 1428–30 could hardly have composed or developed some of the passages in question.

A4

Madonna and Child with Saints
Michael and John the Baptist
fresco, Montemarciano
(near San Giovanni Valdarno),
oratory, 320 x 235 cm.

Until the discovery of the San Giove-

Cat. A3 The *sinopia* of the *Crucifixion* and [underneath] a detail of the mounted knight attributed to Masaccio.

nale painting, some critics thought this might be an early work by Masaccio.

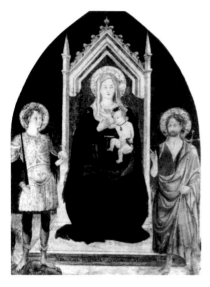

Cat. A4

Scene from the Life of Saint Julian

tempera on cloth on panel,
Florence, Horne Museum,
24 x 43 cm.

The condition of this small painting is

so poor that assured judgements are risky.

Perhaps because of this, most critics seem to agree that it is by Masaccio.

A6

The Agony in the Garden, and the Penitence of Saint Jerome

tempera on cloth on panel,
Altenburg, Lindenau Museum,

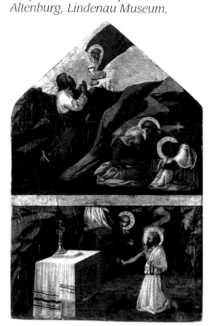

Cat. A6

30 x 34.6, and 20 x 34.5 cm.

Critics are divided over this little picture. Various alternatives have been proposed, but not everyone agrees on them. The young Angelico is presumably also a possibility as the author, or one of his assistants, or even Arcangelo di Cola.

A7

Madonna and Child of Humility,

tempera on cloth on panel,
Washington, D.C., National Gallery,
105 x 53.5 cm.

This painting has been virtually repainted by restorers, so it has always been difficult for critics to take positions on it.

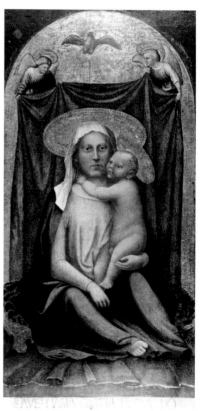

Cat. A7

Cat. A5

Each of the following three portraits is similar in pose and in composition.

A8

Male Portrait
tempera on cloth on panel,
Boston,
Isabella Stewart Gardner Museum,
41 x 30 cm.

Often considered favorably among attributions to Masaccio, the picture becomes problematic when compared with Masaccio's portraits in the Pisa predella, or to those in the Brancacci Chapel. But this painting may also have suffered from repainting.

A9

Male Portrait
tempera on cloth on panel,
Washington, D.C., National Gallery,
42 x 32 cm.

Like the Boston picture, this portrait is often treated favorably when discussed as the work of Masaccio. But it also encounters problems when comparisons are made with Masaccio's known portraits.

A10

Male Portrait
tempera on cloth on panel,
Chambery, Musée des Beaux-Arts,
47 x 36 cm.

Cat. A10

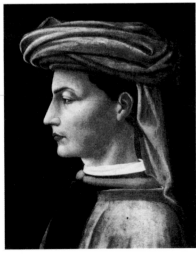

Although the painting is of interest to Masaccio scholars, few think it by him.
It may reflect something that has been lost, by Masaccio.

A11

Two Nudes (Adam and Eve?)
drawing,
Florence, Uffizi, Gabinetto dei Disegni,
19.3 x 9.8 cm,
n. 30F.

Only recently attributed to Masaccio, the drawing still has to be considered by the various scholars.

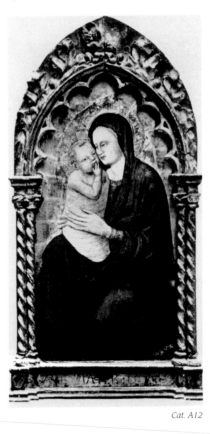

Cat. A12

A12

Giovanni Toscani and Masaccio (?)
Madonna and Child
size and whereabouts unknown.
Panel.

This painting was on the market sometime after the Second World War.

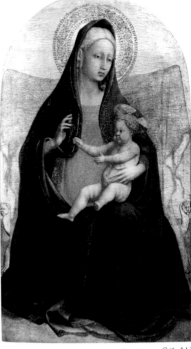

Cat. A13

The Madonna would seem to be by Toscani, the child by Masaccio

A13

Madonna and Child
panel,
size and whereabouts unknown

This painting was also on the market sometime after World War II, and was probably exported from Italy. It may be by Masaccio. The Madonna seems to be the the same woman portrayed in his *San Giovenale* trptych.

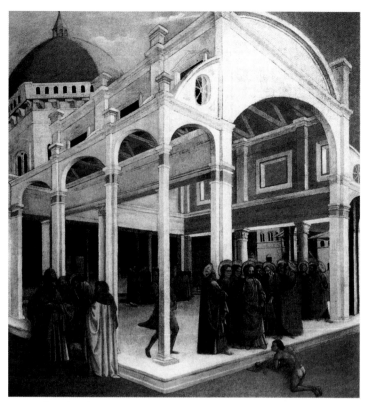

Cat. B1 Liberation of a Man Possessed by the Devil.

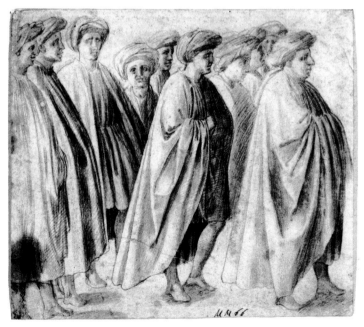

Cat B2 The *Sagra* from the Procacci collection.

II. Two works that reflect lost paintings by Masaccio:

B1

Perspective View of the Inside of a Church with Many Figures
tempera on cloth on panel,
Philadelphia Museum of Art,
Johnson Collection, 115 x 106 cm.

Vasari mentions a picture by Masaccio in the house of Ridolfo del Ghirlandaio, of Christ liberating a boy possessed by the devil. This painting, now in Philadelphia, may reflect the one by Masaccio, or it may not.

B2

The Sagra, or **The Procession to the Consecration of Santa Maria del Carmine** (in 1422)
drawing,
Florence,
Procacci Collection.

Vasari also writes of a terra-verde and chiaroscuro painting that Masaccio did in the cloister of Santa Maria del Carmine in Florence, which contained a procession of Florentine notables. There are a number of extant drawings from this painting, which apparently was destroyed during a remodeling of the church in about 1600. These illustrations are two of the drawings..

Cat. B2 The Sagra from the Museum and Art Gallery, Folkestone.

Topographical Index

Chronological Table

1401

Masaccio was born in Castel San Giovanni, now San Giovanni Valdarno, on Saint Thomas's Day, 21 December 1401. His given name was Tommaso, but in art he became known as Masaccio, a nickname that means something like "Big Tom." His father was a young notary, Ser Giovanni di Andreuccio di Mone; his mother was Monna Jacopa di Martinozzo di Dino.

1406

Masaccio's brother Vittorio, later called Giovanni after his father, and nicknamed Lo Scheggia (Chip), was born after their father's death that same year.

1417

After Ser Giovanni died, Monna Jacopa—Masaccio's mother—remarried a much older man, a druggist in San Giovanni. This man, Tedesco del Maestro Feo, died in 1417.

1418?

Masaccio—age sixteen—appeared as guarantor in a document of the Arte de Legnaioli, for a woodworker from Castel San Giovanni (the exact date is not known), Neri di Cenni Colci da Castel San Giovanni.

1421

Giovanni di Ser Giovanni—Masaccio's brother—is mentioned twice as an assistant in Florence in the shop of the painter Bicci di Lorenzo, on 13 February and on 30 October. Masaccio's brother would have been fifteen years old in 1421.

1422

On 7 January, *Masus S. Johannis Simonis pictor populi S. Nicholai de Florentia* joins the Arte de Medici e Speziali—the guild of doctors and druggists. As druggists traditionally dealt in pigments, their guild was also that for painters. On 6 October, Masaccio pays a two-lira tax for membership. On 9 April, the Church of Santa Maria del Carmine was consecrated: later, Masaccio painted in the cloister of the church a commemorative fresco in terra verde of this event. This painting seems to have been destroyed during a restructuring of the cloister. The date on the San Giovenale triptych is 23 April 1422. The feast of Saints Alexander, Eventius, Theodulus, and Juvenal is 3 May: the last was a bishop in central Italy who died about A.D. 367.

1424

Masaccio joined the Compagnia di San Luca, in Florence.

1425

On 6 June, a painter called "Maso" is paid for gilding some candlesticks for the cathedral at Fiesole. This may be Masaccio. On 18 July, a *Maso dipintore* owes money to Bartolomeo di Lorenzo, *pizzicagnolo*.

1426

Ser Giuliano di Colino degli Scarsi da San Giusto, a notary in Pisa, commissioned Masaccio to paint an altarpiece for him, for the Carmelite church in his city.

Agreement signed: 19 February
First Payment: 20 February 10 florins
Second: "23 March 15"
Third: "24 July 10"
Fourth: "15 October 25"
Fifth: "9 November 3 lire"
Sixth: "18 December 1 florin"
Seventh: "24" 5 grossi (paid to Andrea di Giusto, Masaccio's assistant)
Eighth: "26" 16 florins, 15 soldi

On 15 October, Masaccio had to promise not to do any other work until the commission was completed: Masaccio's brother who is mentioned is called Vittorio in this document.

Masaccio and his brother Lo Scheggia are mentioned as taxed by the "Estimo" of San Giovanni 6 soldi, in a document that is probably of 1426. Or this may simply be a later record of what they paid in 1427 after their *Catasto* tax declarations.

23 August: Masaccio is sued in the Mercanzia court for a debt he owes Tomaso d'Iacopo, a furrier.

Masaccio is still in Pisa (perhaps to oversee the installation of his big polyptych in the chapel for which it was designed?): on 23 January (this is still 1426, according to Florence's then system of dating), he acts as a witness for a notarial document of his patron, Ser Giuliano.

1427

On 29 July, Masaccio files a tax return—the newly instituted *Catasto*—for himself and his brother Giovanni. He states that he's twenty-five years old, his brother is twenty, and his mother is forty-five—so we know that she was twenty when he was born, and that she would have married at age eighteen or nineteen. At that point, they—all three—are living together in Florence in Via dei Servi, and Masaccio has a shared shop near the Badia and the Bargello. Considering that during the year before, Masaccio earned eighty florins doing the Pisa commission, his financial state in mid-1427 is fairly disastrous: he himself owns nothing, and no outstanding income is mentioned; against this, he has debts of forty-four florins. Masaccio and Giovanni's mother is owed one hundred florins for her dowry, forty from the family of Masaccio's father—who'd died twenty-one years before—and sixty from the family of Tedesco del Maestro Feo—who'd died ten years earlier. The mother was also left by Tedesco a small piece of land, and a house: but these items also apparently generate no income. On the reverse of Masaccio's tax declaration, it is noted, in another hand, that "Tomaso di Ser Giovanni dipintore" is of "San Pulinari," in Florence.

1428

On his *Catasto* tax return, a different hand from his has crossed out his name and written in the margin: *Dicesi è morto a Roma*—"he's said to have died in Rome." That Masaccio died in 1428 is not certain, but the painter Niccolò di Ser Lapo in January of 1431 writes in a tax document that Masaccio died in Rome, and his heirs owe Niccolò money.

Bibliography

After the cleaning of the Brancacci Chapel paintings in the 1980s, new photos helped to produce a plethora of publications, particularly by people involved in the restoration. More books and articles on Masaccio have been produced in the last thirty years than were produced in the hundred before.

The bibliography includes most of the published work done in the twentieth century, especially that which appeared after 1950. Other comments can easily be found through the various bibliographies in the books mentioned. Particularly useful is that in Paul Joannides's large catalog of 1993.

Besides writings specifically on Masaccio's painting and life, a few good works have been listed about the history, culture, society, religion, finance, politics, and science of the world in which he lived. It seems to me mistaken to study Masaccio's work without a broad view of the world from which it also sprang.

There are also two videofilms about Masaccio and his work:

Baldini, U., *Masaccio e la Cappella Brancacci*, Firenze (SCALA—Videocast), 1990.

Hauer-Rawlence Ltd. (for BBC 2), *Dealing in Dirt—Every Picture Tells a Story* (about *The Trinity* and the proposal to restore it), London, 1992–93, (co-produced by Hauer, D. and Fremantle, R.).

1990s:

Sodi, S., *La Basilica di San Piero a Grado*, Pisa, 1996.

Davies, N., *Europe: A History*, Oxford, 1996, pp. 383–575.

Spike, J. T., *Masaccio*, Milan, 1995.

Ambrosio, F., *Masaccio*, Milan, 1994.

Goldner, G. R., "Drawing by Masaccio," in *Apollo*, Nov. 1994.

Droandi, A., *Masaccio Pittore di Valdarno*, Arezzo, 1993.

Goldthwaite, R. A., *Wealth and the Demand for Art in Italy 1300–1600*, Baltimore, 1993.

Joannides, P., *Masaccio and Masolino's: A Complete Catalogue*, London, 1993.

Ladis, A., *The Brancacci Chapel*, New York, 1993.

Fremantle, R., *God and Money*, Florence, 1992, pp. 34–40.

(Various Authors), *La Cappella Brancacci*, Milan (Olivetti Quaderni di Restauro), 1992.

Zorzi, R., *La Cappella Brancacci: La scienza per Masaccio, Masolino, e Filippino Lippi*, Milan (Olivetti Quaderni del Restauro No. 10), 1992.

Ambrosio, F., *Masaccio*, Milan, 1991.

Ambrosio, F., ed., *La Cappella Brancacci*, Milan, 1991.

Christiansen, K., "Some Observations on the Brancacci Chapel Frescoes after Their Cleaning," in *The Burlington Magazine* CXXXIII, 1054, Jan. 1991, pp. 5–20.

Shulman, K., *Anatomy of a Restoration: The Brancacci Chapel*, New York, 1991.

Joannides, P., "Masaccio's Brancacci Chapel," in *Apollo* CXXXIII, 347, Jan. 1991, pp. 26–32.

Tintori, L., *Contributo alle Ricerche sulla Tecnica Originale degli Affreschi della Cappella Brancacci nella Chiesa del Carmine a Firenze*, Prato, 1991.

Baldini, U., and O. Casazza, *La Cappella Brancacci*, Milan, 1990.

Berti, L., and A. Paolucci, *L'età di Masaccio*, Milan, 1990.

Casazza, O., *Masaccio and the Brancacci Chapel*, Florence, 1990.

Carmiani, M., *Santa Maria del Carmine*, Florence, 1990.

Caneva, C., ed., *"Masaccio 1422–1989": Dal Trittico di San Giovenale al Restauro della Cappella Brancacci*, Atti del Convegno del 22 Aprile 1989, Pieve di San Pietro a Cascia—Reggello, Figline Valdarno, 1990.

Cocke, R., "Planning the Brancacci Fresco Cycle: The Role of Masaccio," in *Bulletin of the Society for Renaissance Studies* VIII, 1, Oct. 1990, pp. 12–19.

Rosito, M. G., ed., *Masaccio e il Mondo della Rinascenza Fiorentina*, Florence, 1990.

1980s:

Baldini, U., "Primi fatti di Masaccio e Masolino," in *Critica d'Arte* LIV, 1989, pp. 27–35.

Berti, L., and R. Foggi, *Masaccio: Catalogo Completo dei Dipinti*, Florence, 1989.

Casazza, O., and P. C. Lazzeri, *La Cappella Brancacci: Conservazione e Restauro nei Documenti della Grafica Antica*, Modena, 1989.

Field, J. V., and others, "The Perspective Scheme of Masaccio's *Trinity*, in *Nuncius, Annali di Storia della Scienza* IV, 2, 1989, pp. 31–114.

Rossi, P. A., "Lettura del 'Tributo' di Masaccio," in *Critica d'Arte*, 5th series, LIV, 20, Apr.–June 1989, pp. 39–42.

Berti, L., and A. P. Tofani, *Gli Uffizi Studi e Ricerche* 5, Florence, 1984–88.

Baldini, U., "Le figure di Adamo e Eva formate affatto ignude in una cappella di una principale chiesa di Fiorenza," in *Critica d'Arte* LIII, 1988, 16, pp. 72–77.

Belardinelli, A., *Tommaso detto Masaccio tracce di Lettura*, Florence, 1988.

Berti, L., *Masaccio*, Florence, 1988.

Casazza, O., "La grande gabbia architettonica di Masaccio," in *Critica d'Arte*, 4th series, LIII, 16, Jan.–March 1988, pp. 78–87.

Joannides, P., "The Colonna Triptych by Masaccio and Masolino: Chronology and Collaboration," in *Arte Cristiana* LXXVI, 728, Sept.–Oct. 1988, pp. 339–46.

Bober, P., and N. Rubinstein, *Renaissance Artists and Antique Sculpture*, New York, 1987.

Colle, E., *Masaccio*, San Giovanni Valdarno, 1980.

Hills, P., *The Light of Early Italian Painting*, London, 1987.

Pandimiglio, L., *Felice di Michele vir clarissimus e una consorteria i Brancacci di Firenze*, Milan (Olivetti Quaderni del Restauro no. 3), 1987.

Baldini, U., "Restauro della Cappella Brancacci: Primi Risultati," in *Critica d'Arte* IX, 1986, pp. 65–68.

Strehlke, C., and M. Tucker, "The Santa Maria Maggiore Altarpiece: New Observations," in *Arte Cristiana* LXXV, 719, Mar.–Apr. 1987, pp. 105–24.

Casazza, O., "Il Ciclo delle Storie di San Pietro e la 'Historia Salutis': Nuova Lettera della Cappella Brancacci," in *Critica d'Arte*, 4th series, LI, 9, Apr–June 1986, pp. 68–84.

Covi, D. A., *The Inscription in Florentine Fifteenth-Century Painting*, New York, 1986.

Kemp, W., "Masaccio's Trinità in Kontext," in *Marburger Jahrbuch für Kunstwissenschaft* 21, 1986, pp. 45–72.

Jacobson, W., "Die Konstruktion der Perspektive bei Masaccio und Masolino in der Brancacci Kapelle," in *Marburger Jahrbuch für Kunstwissenschaft* 21, 1986, pp. 73–92.

Baldini, U., "Nuovi affreschi nella Cappella Brancacci Masaccio e Masolino," in *Critica d'Arte* XLIX, 4th series, 1, Mar. 1984, pp. 65–72.

Bradshaw-Nishi, M. J., "Masolino's Saint Catherine Chapel, San Clemente, Rome: Style, Iconography, Patron and Date," Ph.D. thesis, U. of Indiana, 1984 (Univ. Microfilms, Ann Arbor, Mich.).

Micheletti, E., "Masaccio Trittico di San Giovenale," in *Masaccio e l'Angelico: Due Capolavori Della Diocesi di Fiesole*, Fiesole, 1984, pp. 14–25.

Procacci, U., and U. Baldini, *La Cappella Brancacci nella Chiesa del Carmine a Firenze*, Milan (Olivetti Quaderni del Restauro no. 1), 1984.

Querci, R., "The Casini Madonna," in *L'opera ritrovata, omaggio a R. Siviero*, Florence, 1984, no. 31, p. 93.

Raspini, G., "Chiesa di San Giovenale a Cascia," in *Masaccio e l'Angelico: Due Capolavori della Diocesi di Fiesole*, Fiesole 1984, pp. 26–28.

Rensi, A., "The Ex-Contini-Bonacossi Madonna of Humility," in *L'opera ritrovata omaggio a R. Sievero*, Florence, 1984, no. 19, p. 78.

Wakayama, E. M. L., "Lettura iconografica degli affreschi della Cappella Brancacci: Analisi dei gesti e della composizione," in *Commentari*, XXIX, 1/4, 1978 (1984), pp. 72–80.

Brucker, G. A., *Firenze 1138–1737: L'Impero del Fiorino*, Verona, 1983.

Procacci, U., "Masaccio e la sua famiglia negli antichi documenti," in *La Storia del Valdarno*, San Giovanni Valdarno, 1980–83, vol. 2, pp. 553–59.

Fremantle, R., "Masaccio," in L. Gowing, ed., *A Biographical Dictionary of Artists*, London, 1983, pp. 423–25.

Raspini, G., "Il Quadro di Masaccio nella Chiesa di S. Giovenale," in *La Parola*, 25 Dec. 1983.

Cennini, C., *Il Libro dell' Arte*, Vicenza, 1982.

Claster, J. N., *The Medieval Experience 300–1400*, New York, 1982

Padoa Rizzo, A., "Sul Polittico della Cappella Ardinghelli in Santa Trinita e Giovanni Toscani," in *Antichità Viva* XXI, 1, Jan.–Feb. 1982, pp. 5–10.

Gould, C., "On the Direction of Light in Italian Renaissance Frescoes and Altarpieces," in *Gazette des Beaux-Arts*, VI Période, XCVII, no. 1344, Jan. 1981, pp. 20–25.

Wackernagel, M., *The World of the Florentine Renaissance Artist*, Princeton, 1981.

Cole, B., *Masaccio and the Art of Early-Renaissance Florence*, Bloomington, Ind., 1980.

Goffen, R., "Masaccio's Trinity and the Letter to Hebrews," in *Memorie Domenicane* II, 1980, pp. 489–504.

Goldstein, I., *Dawn of Modern Science*, Boston, 1980.

Procacci, U., *Masaccio*, Florence, 1980.

Raspini, G., "S. Giovenale," in *La Parola*, 11 May 1980.

1970s:

Hertlein, E., *Masaccio's Trinität, Kunst Geschichte und Politik der Frührenaissance in Florenz*, Florence, 1979.

Takcas, J., *Masaccio*, Budapest, 1979.

Bellosi, L., "The Ex-Contini-Bonacossi 'Virgin of Humility,' " in *Lorenzo Ghiberti, Materia e ragionamenti*, Florence, 1978–79 (catalog), p. 152.

Amaducci, A. B., *The Brancacci Chapel and the Art of Masaccio*, Florence, 1978.

Beck, J., and G. Corti, *Masaccio: The Documents*, Locust Valley, N.Y., 1978.

Fremantle, R., "Riferimenti a membri della famiglia Brancacci da parte dello stesso notaio Filippo di Cristofano"; and "Note sulla parentela di Mariotto di Cristofano con la famiglia di Masaccio," both in *Antichità Viva* XVII, 3, 1978, pp. 50–53.

Kane, E., "The Painted Decoration of the Church of San Clemente," in L. Dempsey, ed., *San Clemente Miscellany*, II, 1978, pp. 60–151.

Kent, D., *The Rise of the Medici*, Oxford, 1978.

Petrioli Tofani, A., *Masaccio*, Florence, 1978.

Smart, A., *The Dawn of Italian Painting*, Oxford, 1978.

Fremantle, R., "Ricerche Documenti d'Archivio," in *Antichità Viva* XVI, 3, 1977, pp. 69–70.

Hale, J. R., *Florence and the Medici*, London, 1977.

Molho, A., "The Brancacci Chapel: Studies in Its Iconography and History," in *Journal of the Warburg and Courtauld Institutes* 40, 1977, pp. 50–98.

Teuffel, C. G. von, "Masaccio and the Pisa Altarpiece: A New Approach," in *Jahrbuch der Berliner Museen* XIX, 1977, pp. 23–68.

Beck, J., "Fatti di Masaccio," in *In Memoriam Otto J. Brendel: Essays in Archaeology and the Humanities*, Mainz, 1976, pp. 211–14.

Cole, R. V., *Perspective for Artists*, New York, 1976.

Egerton, S., *The Renaissance Rediscovery of Linear Perspective*, New York, 1975.

Fremantle, R., *Florentine Gothic Painters*, London, 1975, pp. 493–522.

Fremantle, R., "Some New Masolino Documents," in *The Burlington Magazine*, 1975, pp. 658–59.

Mead, R. D., *Europe Reborn*, New York, 1975.

Hibbert, C., *The Rise and Fall of the House of Medici*, London, 1974.

Fremantle, R., "Some Documents concerning Masaccio and His Mother's Second Family," in *The Burlington Magazine*, 1973, pp. 516–19.

Watkins, L. B., "Technical Observations on the Brancacci Chapel Frescoes," in *Mitteilungen des Kunsthistorischen Instituts in Florenz* XVII, 1973, pp. 65–74.

Baxandall, M., *Painting and Experience in Fifteenth-Century Italy*, Oxford, 1972.

Beck, J., "Masaccio's Early Career as a Sculptor," in *Art Bulletin* LIII, 2, Jan. 1971, pp. 177–95.

Brucker, G., *The Society of Renaissance Florence*, New York, 1971.

Castelnuovo-Tedesco, L., *The Brancacci Chapel in Florence*, Los Angeles, 1971 (Ph.D. thesis, UCLA; Univ. Microfilms, Ann Arbor, Mich.).

Fremantle, R., *Florentine Painting in the Uffizi*, Florence, 1971, pp. 106–16.

Larner, J., *Culture and Society in Italy 1290–1420*, London, 1971.

Procacci, U., "Masaccio," in *Encyclopaedia Universalis*, Paris, 1971, pp. 582–84.

Fremantle, R., "Masaccio e L'Angelico," in *Antichità Viva* IX, 6, Nov.–Dec. 1970, pp. 39–49.

Smith, J. H., *The Great Schism 1378*, London, 1970.

Southern, R. W., *Western Society and the Church in the Middle Ages*, Harmsworth, 1970.

Watkins, L. B., *The Brancacci Chapel Frescoes—Meaning and Use*, University of Michigan, 1970 (Ph.D. thesis).

1960s:

Brucker, G. A., *Renaissance Florence*, Berkeley, 1969.

Del Bravo, C., *Masaccio Tutte le Opere*, Florence, 1969.

Fremantle, R., "Masaccio e l'Antico," in *Critica d'Arte* XXXIV, 1969, pp. 39–56.

Fremantle, R., "Perché Proprio Florence?" in *Antichità Viva* VIII, 6, Nov.–Dec. 1969, pp. 22–25.

Holmes, G., *The Florentine Enlightenment*, London, 1969.

Zeri, F., "Opere Maggiori di Arcangelo di Cola," in *Antichità Viva* VIII, 6, 1969, pp. 5–15.

Barraclough, G., *The Medieval Papacy*, London, 1968.

Procacci, U., et al., *The Great Age of Fresco*, New York, 1968.

Rubinstein, N., ed., *Florentine Studies*, London, 1968.

Sellheim, R., "Die Madonna mit der Schahâda," in E. Graf, ed., *Festschrift Werner Caskel*, Leiden, 1968, pp. 308–15.

Vitalini Sacconi, G., *La Scuola Camerinese*, 1968.

Volponi, P., and L. Berti, *L'opera completa di Masaccio*, Milan, 1968.

Berti, L., *Masaccio*, University Park, Pa., 1967.

Einem, H. von, "Zur Deutung von Masaccios 'Zinsgroschen,' " in *Acta Historiae Artium* XIII, 1/3, 1967, pp. 187–90.

Janson, H. W., "Ground Plan and Elevation in Masaccio's Trinity Fresco," in *Essays in the History of Art Presented to Rudolph Wittkower*, London, 1967, pp. 83–88.

Bellosi, L., "Giovanni di Francesco Toscani," in *Paragone* XVII, 193, Mar. 1966, pp. 44–58.

Bologna, F., *Masaccio*, Milan, 1966.

Chiarini, M., *Masaccio e la pittura del '400 in Toscana*, Milan, 1966.

Hale, G., *The Technique of Fresco Painting*, New York, 1966.

Merryfield, M., *The Art of Fresco Painting*, London, 1966.

Parronchi, A., *Masaccio*, Florence, 1966.

Shearman, J., "Masaccio's Pisa Altarpiece: An Alternative Reconstruction," in *The Burlington Magazine* CVIII, 762, Sept. 1966, pp. 449–55.

Simson, O. von, "Über die Bedeutung von Masaccios Trinitätfresko," in *Jahrbuch der Berliner Museen* VIII, 1966, pp. 119–59.

Bologna, F., *Masaccio: La Cappella Brancacci*, Milan, 1965.

Procacci, U., *Masaccio: La Cappella Brancacci*, Florence, 1965.

Shell, C., "Francesco d'Antonio and Masaccio," in *Art Bulletin* XLVII, 4 Dec. 1965, pp. 465–69.

Tolnay, C. de, "Note sur l'Iconogrohie des fresques de la Chapelle Brancacci," in *Arte Lombarda* X, 1965, pp. 69–74.

Bainton, R. H., *Christendom*, vol. 1, New York, 1964.

Berti, L., *Masaccio*, Milan, 1964.

Meiss, M., "The Altered Program of the Santa Maria Maggiore Altarpiece," in W. Lotz and L. L. Möller, eds., *Studien zur Toskanischen Kunst: Festschrift für L. H. Heydenreich*, Munich, 1964, pp. 169–90.

Meiss, M., "Masaccio and the Early Renaissance: The Circular Plan," in *Studies in Western Art*, Princeton, 1963, II, pp. 134–43.

Roover, R. de, *The Rise and Decline of the Medici Bank, 1397–1494*, Cambridge, Mass., 1963.

Martines, L., *The Social World of the Florentine Humanists*, Princeton, 1963.

Schlegel, U., "Observations on Masaccio's Trinity Fresco," in *Art Bulletin* XLV, 1, Mar. 1963, pp. 19–33.

Vasari, G., *The Lives of the Painters, Sculptors, and Architects*, London, 1927–63.

Baldini, N., "Masaccio," in *Enciclopedia Universale dell'Arte* VIII, 1962, pp. 866–77.

Berti, L., "Masaccio a San Giovenale a Cascia," in *Acropoli* II, 1962, pp. 149–65.

Cassa di Risparmio di Modena, *Masaccio*, 1962.

Ferguson, W. K., *Europe in Transition, 1300–1520*, Boston, 1962.

Heer, F., *The Medieval World*, New York, 1962.

Berti, L., "Masaccio 1422," in *Commentari* XII, 2 June 1961, pp. 84–107.

Kristeller, P. O., *Renaissance Thought*, New York, 1961.

Brandi, C., *Masaccio*, Palermo, 1961 (Dispense corso universitario).

Pracacci, U., *Sinopie e Affreschi*, Milan, 1961.

Hay, D., *The Italian Renaissance in Its Historical Background*, Cambridge, 1961.

Borsook, E., *The Mural Painters of Tuscany*, London, 1960.

Burckhardt, J., *The Civilization of Renaissance in Italy*, London, 1960.

Meller, P., "Cappella Brancacci, Problemi Ritrattistici e Iconografici," in *Acropoli* I, 1960–61, pp. 186–227; IV, pp. 273–312.

1950s:

Offner, R., "Light on Masaccio's Classicism," in *Studies in the History of Art Dedicated to William E. Suida*, London, 1959, pp. 66–73.

Partner, P., *The Papal State under Martin V*, London, 1958.

Tolnay, C. de, "Renaissance d'une fresque" in *L'Oeil* 37, Jan. 1958, pp. 30–41.

Viardo, P., *Masaccio (1401–28)*, Milan, 1958.

Brandi, C., "I Cinque Anni Cruciali per la Pittura Fiorentina del '400," in *Studi in Onore di Matteo Marangoni*, Florence, 1957, pp. 167–75.

Origo, I., *The Merchant of Prato*, London, 1957.

White, J., *The Birth and Rebirth of Pictorial Space*, London, 1957.

Hendy, P., *Masaccio Frescoes in Florence*, Greenwich, Conn., 1956.

Huizinga, J., *The Waning of the Middle Ages*, London, 1955.

Morisani, O., "Art Historians and Art Critics," III: Cristoforo Landino, in *The Burlington Magazine* XCV, 1953, p. 170.

Murray, P., "Art Historians and Art Critics, IV; XIV Uomini Singolari in Florence," in *The Burlington Magazine* XCIX, 1957, p. 335.

Procacci, U., "Sulla cronologia delle opere di Masaccio e di Masolino tra il 1425 e il 1428," in *Rivista d'Arte* XXVII, 1953, pp. 3–55.

Gilmore, M. P., *The World of Humanism*, New York, 1952.

Salmi, M., "Gli Scomparti della Pala di S. M. Maggiore acquistati dalla National Gallery," in *Commentari* III, 1952, pp. 14–21.

Clark, K., "An Early Quattrocento Triptych from Santa Maria Maggiore, Rome," in *The Burlington Magazine*, 584, XCIII, Nov. 1951, pp. 339–47.

Meiss, M., *Painting in Florence and Siena after the Black Death*, Princeton, 1951.

Procacci, U., *Tutta la Pittura di Masaccio*, Milan, 1951.

Longhi, R., *Masaccio*, Milan, s.d. (Pirelli), ?1950.

Salmi, M., *Masaccio, Masaccio-Masolino, Filippino Lippi, La Cappella Brancacci a Firenze*, 2 vols., Milan (Amilcare Pizzi), s.d. (ca. 1950–55).

Pre-1950:

Antal, F., *Florentine Painting and Its Social Background*, London, 1948.

Ferguson, W., *The Renaissance in Historical Thought*, Boston, 1948.

Salmi, M., *Masaccio*, Milan, 1948.

Steinbart, K., *Masaccio*, Vienna, 1948.

Longhi, R., "Fatti di Masolino e di Masaccio," in *Critica d'Arte* XXV–XXVI, 1940–41, pp. 145–91.

Lavagnino, E., "Masaccio—Dicesi è Morto a Roma," in *Emporium* XCVII, Mar. 1943, pp. 97–112.

Oertel, R., "Wandmalerei und Zeichnung in Italien," in *Mitteilungen des Kunsthistorischen Instituts in Florenz* VII, 1940, pp. 217–314.

Gutkind, C., *Cosimo de Medici Il Vecchio*, Florence, 1940.

Cheney, E. P., *The Dawn of a New Era: 1250–1453*, New York, 1936.

Schevill, F., *Medieval and Renaissance Florence*, vol. 2, New York, 1936.

Pittaluga, M., *Masaccio*, Florence, 1935.

Brandi, C., "Ein 'Desco da Parto' und seine Stellunginnerhalb, der Toskanischen Malerei nach dem Tode," in *Jahrbuch der Preussischen Kunstsammlungen* LV, 1934, pp. 154–80.

Oertel, R., "Masaccio und die Geschichte der Freskotechnik," in *Jahrbuch der Preussischen Kunstsammlungen* LV, 1934, pp. 229–40.

Procacci, U. "Documenti e Ricerche sopra Masaccio e la sua famiglia," in *Rivista d'Arte*, 2d series, XIV, 1932, pp. 489–503; XVII, 1935, pp. 91–111.

Toesca, P., "Masaccio," in *Encyclopaedia Italiana* XXII, 1934.

Carra, C., *Impressioni su Masaccio*, Arezzo, 1931 (da *Il Vasari*, VI, 1–2).

Lindberg, H., *To the Problem of Masaccio and Masolino*, Stockholm, 1931.

Berenson, B., "A New Masaccio," in *Art in America* XVIII, Feb: 1930, pp. 45–53.

Giglioli, O. H., *Masaccio*, Roma, 1930.

Giglioli, O. H., *Masaccio*, Florence, 1928.

Schmarsow, A., *Masolino und Masaccio*, Leipzig, 1928.

Somaré, E., *Masaccio*, Milan, 1928.

Mesnil, J., *Masaccio et les Débuts de la Renaissance*, The Hague, 1927.

Mesnil, J. "Masaccio and the Antique," in *The Burlington Magazine* XLVIII, Feb. 1926, pp. 91–98.

Marle, R. Van, *The Development of the Italian Schools of Painting*, The Hague, 1923–38.

Giglioli, O. H., *Masaccio*, Florence, 1921.

Mesnil, J., "Masaccio et la théorie de la Perspective," in *Revue de l'Art ancien et moderne* XXXV, Feb. 1914, pp. 145–56.

Berenson, B., *Florentine Painters of the Renaissance*, London, 1909.

Salembier, L., *The Great Schism of the West*, London, 1907.

Milanesi, G., *Le Opere di Giorgio Vasari*, Florence, 1906.

Magherini-Graziani, G., *Masaccio*, 1903.

Milanesi, G., *Operette istoriche di Antonio Manetti*, Florence, 1887.

Vasari, G., *Le Vite de' più eccellenti architetti, pittori et scultori italiani da Cimabue insino a tempi nostri*, Florence, 1550 and 1568.